Installations and Experimental Printmaking

ALEXIA TALA

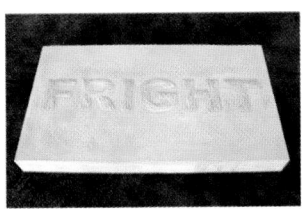

A & C BLACK ■ LONDON

I dedicate this book to my father, Fuad Tala, who believed in me at all times.

FRONTISPIECE: *Radiant* (Detail), Marilene Oliver, 2005, inkjet print on acrylic, 19.7 × 27.5 × 39.4in. / 50 × 70 × 100cm.
TITLE PAGE: *First Memory* (Detail), Alexia Tala, *2008*, woodcut moulded onto plaster.

First published in Great Britain in 2009
A & C Black Publishers Limited
36 Soho Square
London W1D 3QY
www.acblack.com

ISBN: 978-07136-8807-8

Typeset in 10.5 on 13pt Minion

Book design by Susan McIntyre
Cover design by Sutchinda Rangsi Thompson
Commissioning Editor: Susan James
Managing Editor: Sophie Page
Proofreader: Jo Waters

Printed and bound in China

A & C Black uses paper produced with elemental chlorine-free pulp, harvested from managed sustainable forests.

*Installations and
Experimental
Printmaking*

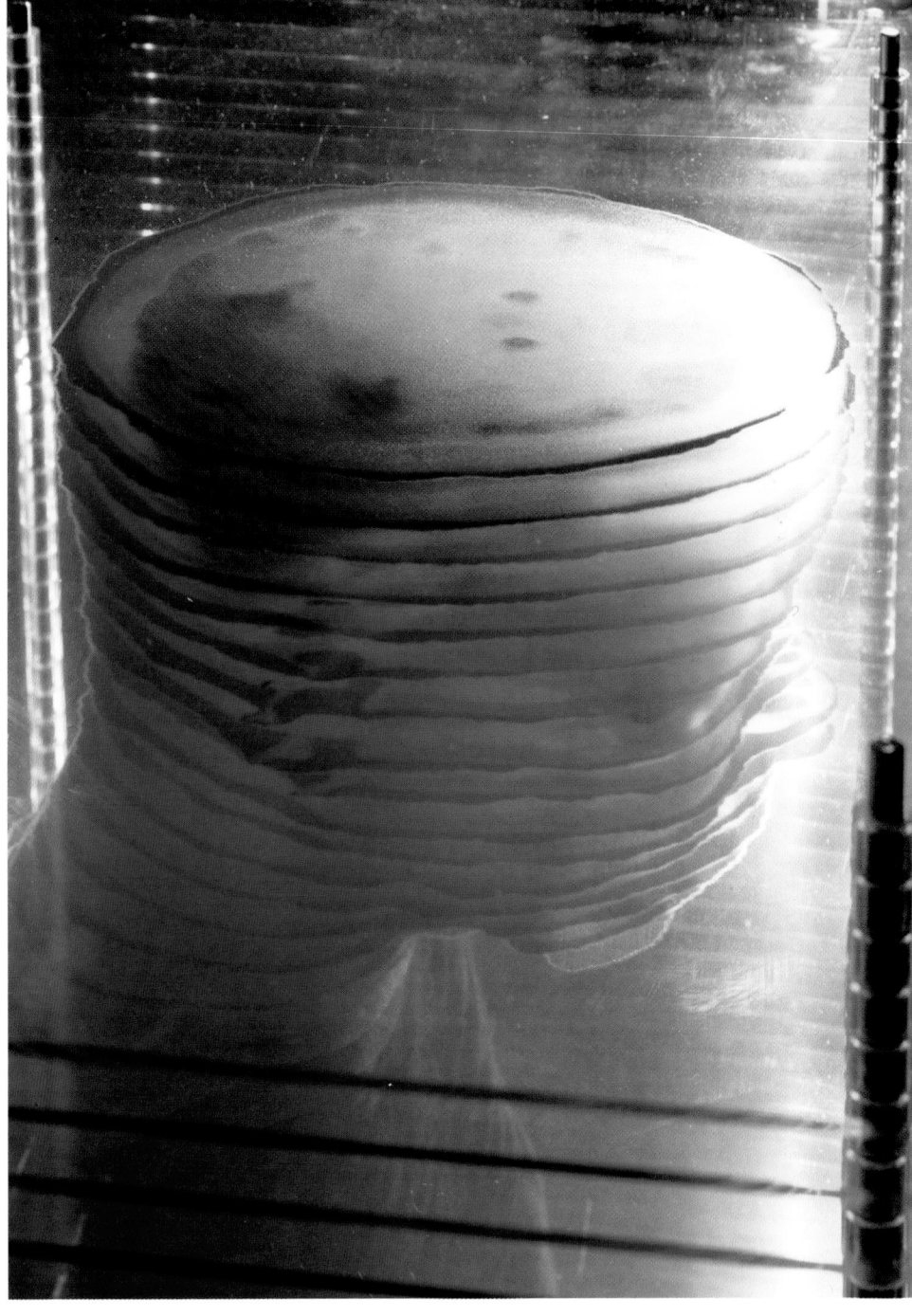

CONTENTS

Acknowledgements

My thanks go to my sons Thomas and Daniel and their father, Stephen, for their continuous support, to all the artists and gallery directors who contributed with their information and images for the book, and to Alejandra Tala, Julia Grimshaw, Gustavo Arroniz and Catalina Binder.

I am grateful to Janet Curley Cannon, who acted as my assistant collecting most of the UK information and to Brenda Hartill for believing in my research and recommending me to the publisher. Special thanks to Susan James and Sophie Page at A&C Black for their patience and guidance.

INTRODUCTION

■ How do you define what a print is? Where do you place the boundary? These are the first questions that will be raised by the work of the artists featured in this book.

The definition of a print in the past was very clear and limited: an image that can be reproduced as part of an edition (either limited or unlimited). Printmaking was considered the democratic art discipline. The cost and reproducibility of the work allowed prints to be sold at a more affordable price than paintings, the commercial galleries could profit from the print sales and artists could show non-commercial work at the same time, which appealed to their creativity.

Art disciplines in the past were pigeon-holed and printmaking was always seen as closer to the craft traditions, based on the technique: clean edges, flat paper and usually shown framed and hung on the wall behind glass.

Traditionally, in order to contain and surround works of art, there has always been the need for a frame. The frame isolates the piece from the wall, forming a barrier against the environment, protecting the piece, or decorating the work. In the *Rhetoric of the Frame* by Paul Duro, Deepack Ananth contributed an essay in which he described the purpose of framing: 'to frame is to create a site – at once a physical locus and a metaphysical locale – for the work of art, and thereby to establish a specific context in which it is to be experienced' (*Duro, 1996, p.153*).

Back in the sixties different disciplines started merging. Remarkable artists such as Richard Hamilton and Robert Raushenberg used silkscreen on canvases, Andy Warhol also made canvases on a massive scale and 3-D objects like the famous Brillo pad boxes, and Kiki Smith printed on cloth and made soft sculpture with it.

Amazing initiatives took place in different parts of the world; a remarkable example is the one by Kenneth Tyler, who created Gemini GEL, which then became Tyler Graphics studio and moved to Mount Kisco close to New York. It was a totally experimental printmaking studio where there were no restrictions except the imagination and creativity of the artists. Nicholas Serota says in the foreword of the book published to commemorate the Tyler gift to the Tate: 'Tyler forged ambitious collaborations with artists and fully exploited the different print media' (*Tate, 2004, p.7*). Iconic pieces were created as a result of the collaborations Ken Tyler had with different artists, such as the *Moby Dick* engravings by Frank Stella, where he printed on domed plates specially created for that project. Other examples are the big paper pulp swimming pool pieces

made by David Hockney or Anthony Caro's printed paper sculpture *Dusty*.

Today in the UK, we have many examples: Damien Hirst's spinning etching series published by Paragon Press, which experiments with the simple but creative way he makes the plates; and Julian Opie creates movement on his prints by the use of lenticular, a serrated plastic which prints on different layers/angles, thereby giving the illusion of motion.

Today the definition of a visual artist encompasses the use of many disciplines in their practice and the blurring of boundaries which characterises contemporary practice. Framing and hanging is not a 'must' anymore and printing on paper isn't either.

On the other hand, the viewer is used to crossing borders in art practice, where artists are not confined and restricted to using only one discipline in their work. Visual artists today have the freedom to move through disciplines that communicate what they wish on a particular project or artwork.

The contemporary artist makes use of traditional printmaking techniques to make work which becomes 3-D objects or installations and even moving image pieces and animations. Artists have allowed themselves to leave the conventions of printmaking behind and have dared to do the unthinkable to prints or to print on unconventional surfaces, which has resulted in their work developing in different ways. When artists show their work today, they do not intend to technically educate; they want to communicate their ideas and to highlight their concerns.

Art practice has been shifting at great speed over the last 15 years. Today we can see printmaking as an equal to other visual art disciplines. The cutting edge of print is moving ever forward. I started my research in 2003 and it is difficult to keep abreast of continuous new developments.

Prints today can take many different forms, from a printed sheet of paper to an object, a movie, or an installation; Marilene Oliver brings the 'internal portrait' into three dimensions by using scanned images from an MRI scanner (medical software) and making them into sculpture.

Prints can be used at an exhibition as souvenirs for the viewer, as John Hitchcock did with his exhibition *Ritual Device*. Prints are also used for public art commissions and site specific projects: for example, see work by Thomas Kilpper.

Artwork has even been made available on the internet for the public to download. Gilbert and George took the extraordinary step of placing an advertisement in *The Guardian* with a link to download and print your own G+G whilst they had a major retrospective exhibition at the Tate Modern.

'Prints are a vital and vibrant link between the museum and the market place, the elite and the every day.'
(*Prints Now: Directions and Definitions*, Saunders and Miles, 2006, p.10)

This book investigates current printmaking practice and shows the work of many contemporary practitioners, emphasising the importance of the artist's thinking as well as the technical aspects each of them had to go through. It is important for the reader to use this book as an eye opener to the endless possibilities of experimentation with process and display.

This book also looks at the use of new technologies. The use of digital technologies is the major change in this discipline. Digital prints are considered as valid a technique as any other traditional one. The debate about whether digital work is fully considered printmaking, or whether a digital print which is not done by the artists hand is an 'original print', has been going on for a while. Even though traditional printmakers can see digital printing as a threat, it is a fact that digital advances are what has allowed artists to expand their vision and options for production. Also, photography has been able to become part of the discipline and has merged with printmaking.

The research focuses on artists who have a total openness towards the processes and materials used to produce their artwork, and also on the space for display, concentrating mainly on installations and 3-D works, thus expanding the definitions of printmaking.

The book is divided into two sections to reflect the two ways in which it approaches the word 'experimental'. The first section concerns the use of traditional techniques while experimenting on a wide range of different materials and surfaces to either print or make the plates or matrices. The second section is about experimenting with display. Some artists use traditional techniques but display in unusual ways through the exploration of materials and space.

I would like to conclude by quoting Paul Klee's thoughts on 2-D work.

'The activity of the spectator is a two dimensional one. He brings each part of the picture into his field of vision and in order to see another he must leave the one just seen'

(*Paul Klee statements by the artist*, Klee, 1945, p.12)

Of all the artists studied in this book who are not distancing their artwork from the viewer by framing a good example is Nicola López, whose work was exhibited at *Since 2000: Printmaking Now* at MoMA in 2006. Her work jumps from wall to wall and from ceiling to floor, making full use of the possibilities of the space. There are some artists whose work is not fully detached from the wall but who trigger other senses in order to achieve that greater connection with the viewer, stimulating non-visual senses, as in the case of Brenda Hartill's encaustic collagraph print assemblages or Kaori Maki's textural surfaces. In both cases, the viewer is experiencing the artwork. We do not need to leave one part of the artwork in order to experience the rest. The artwork is kept deep in our archive of experiences.

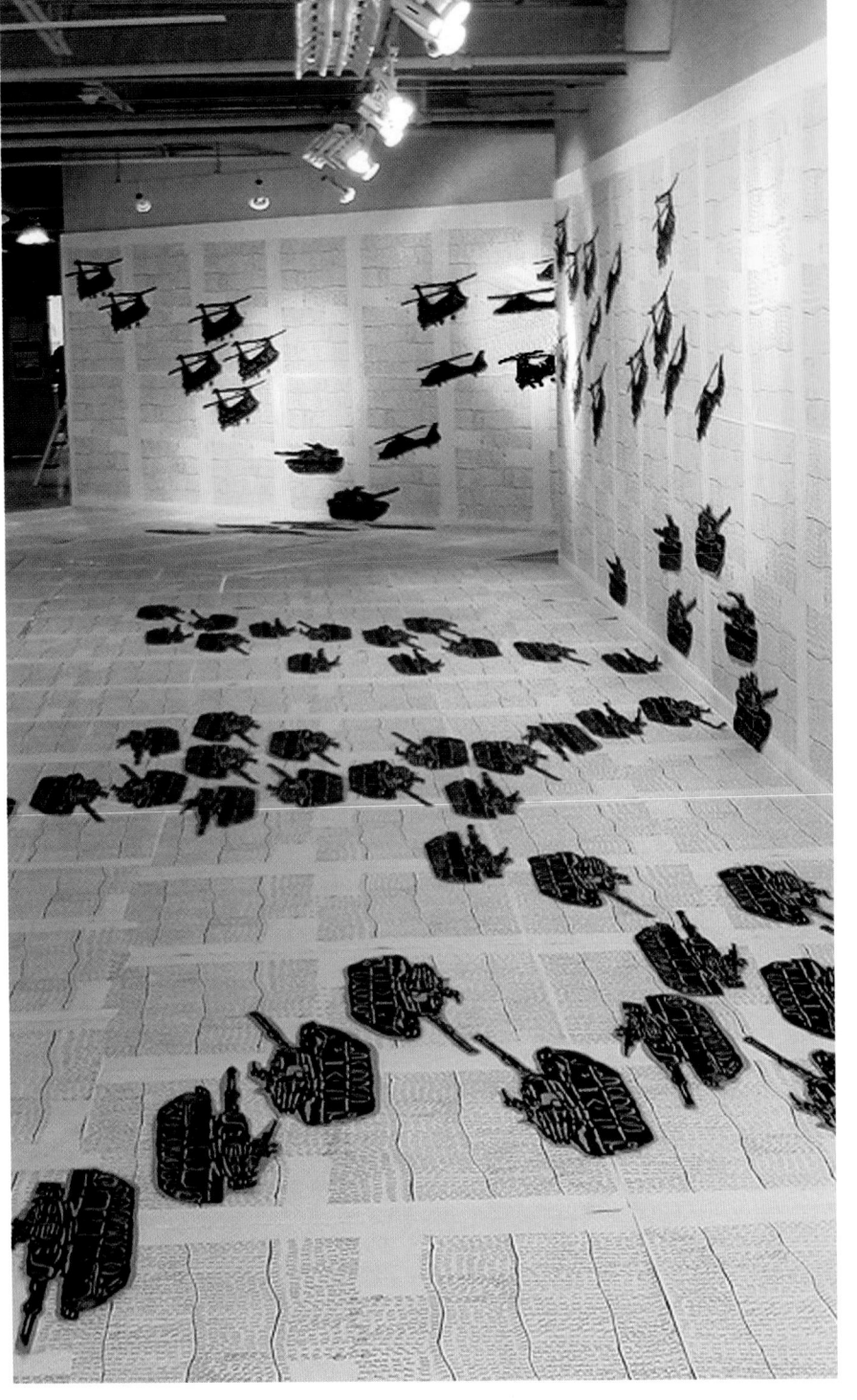

Part 1

EXPERIMENTING WITH TECHNIQUES

■ The first part of this book looks at artists who have crossed the boundaries of the 'traditional' in many senses, and who experiment with a wide range of different materials and surfaces to either print or create the printing plates.

These artists are either using traditional techniques for plate making but printing in unconventional materials or actually inventing their own methods for etching plates, or using non art materials for producing the printing plates. Kaori Maki uses Perspex instead of metal or wood, or Agathe Sorel and Alexia Tala use sand instead of inks; some of the artists just skip the printing altogether and use the plates as artwork in itself.

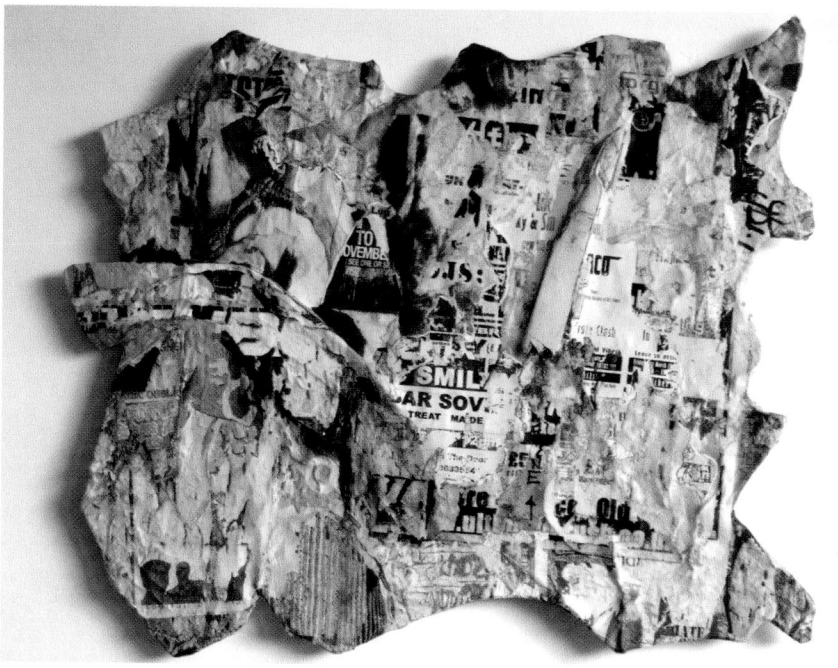

Above: *United Text*, Janet Curley Cannon, 2008, collage of digital prints on various papers on a low relief surface. 20 × 24 × 1 in. / 50 × 60 × 3cm.
Opposite: *They're moving their feet - but nobody`s dancing*, John Hitchcock, 2007, large-scale variable size screenprint action.

■ 1.1 MIXING PRINT TECHNIQUES AND ENCAUSTIC

Encaustic monoprints

The most basic form of printing is monoprinting. Monoprints have been created in the past by making marks on a metal or Perspex plate and then transferring the image onto paper by pressing it against the paper.

Nowadays artists have been experimenting with similar ways of transferring images, making one-offs, but altering the method of printing using encaustic sticks instead of inks. It was Dorothy Furlong, an American artist who lives and works in New Orleans, who developed the encaustic monoprints technique.

The basics for printing with encaustics include a home made hotbox, as shown in the picture: this is a wooden box with four 100 watt lightbulbs and a dimmer switch to regulate the heat that the lightbulbs will be reflecting. The inside of the box is covered with metallic insulation padding to reflect the heat.

To make your image, you won't use ink but encaustic sticks, which are made out of a mixture of beeswax, paraffin wax, dammar resin and pigment.

In order to print an image, you heat the surface of the hotbox and draw with your sticks, which will melt onto the surface but will not lose the shape of the desired image; then you place the paper on top of the image and press it against the aluminium plate with a barin (ideally made of bamboo).

Different artists have used this technique in different ways, to make framable prints but also to create installations.

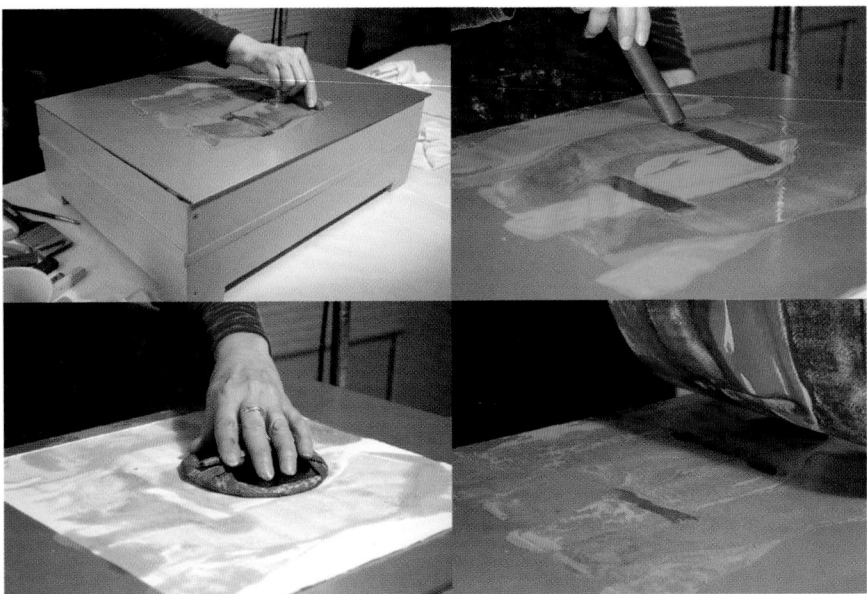

Stages of encaustic monoprints process. Materials: hotbox, encaustic crayons and Japanese paper.

Paula Roland (USA): Encaustic monoprints

Paula lives and works in Santa Fe, New Mexico. She is fascinated by ideas from quantum mechanics, with the uncertainties, mysteries and paradoxes found in nature, and in nature's collision with culture.

She embraces the elements of unpredictability in the techniques and processes she uses.

The installation *Chant* was started shortly after the 9/11 tragedy at the World Trade Center, and in response to it. The series *Chant* relates the patterned, repetitive qualities found in her work to the ancient healing properties of ancient chants.

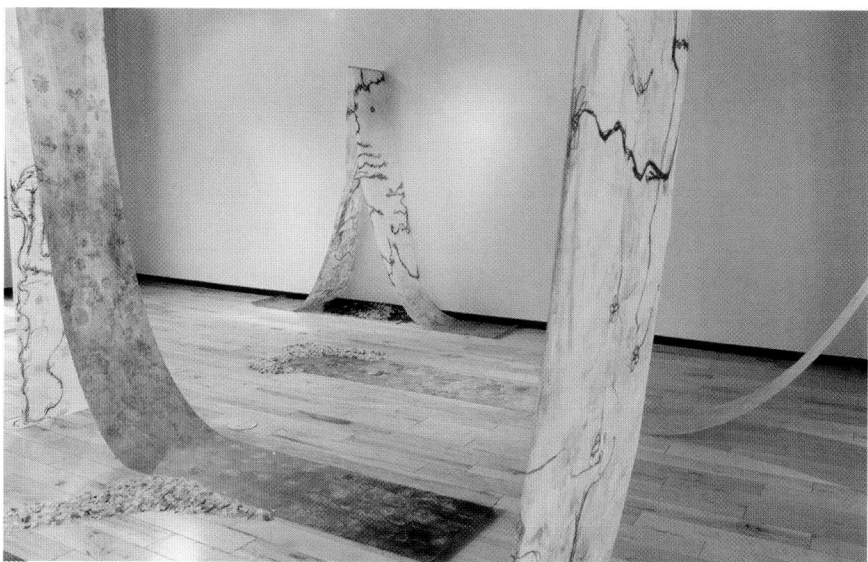

Chant (Detail), Paula Roland, 2003, encaustic monoprint and graphite hand drawing on scrolls of Japanese Paper. Variable sizes.

'Chants have existed throughout the centuries and across cultures, in the Kabalah, in Catholicism's Gregorian Chants, and in Buddhist chants, to name a few. I believe chanting bypasses the conscious mind and provides access to other realms. Among the Shipibo Canibo peoples of Peru, it is said that the shaman's repetitive chants induce a healing transformation in those seeking help. The people of the village then interpret these sounds as patterns and incorporate them in their weavings and pottery. Only when the chant becomes visible is the healing complete. I see my patterned wax drawings and flower prints as my prayers made visible. They are visual and spiritual expressions for peace and the healing of the earth. As with the Shipibo Canibo, the viewer helps complete my prayer when *Chant*'s beauty is shared.'

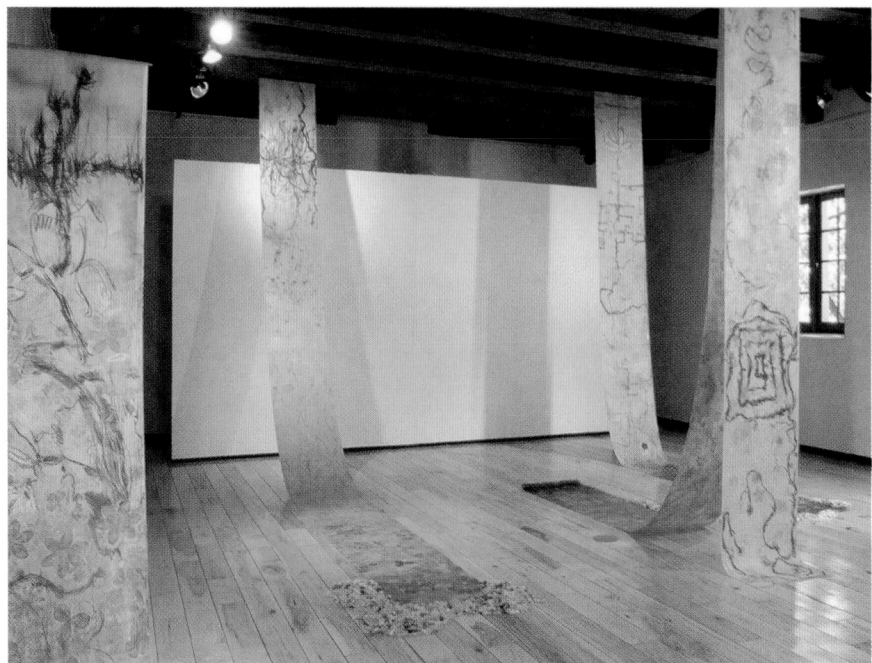

Chant, Paula Roland, 2003, encaustic monoprint and drawing on Japanese paper. Five scrolls of 18in./ 46cm width and up to 24 feet (7m) long. The pieces hang from ceiling to floor. The translucency of the paper allows images to be seen from both sides.

These pieces, on scrolls of paper up to 24 feet (7 metres) in length, hang from the ceiling or wall and pool onto the floor, connecting heaven and earth in 3-D space. The chant series consists of encaustic prints of flowers and graphite drawings relating to nature. The beeswax makes the paper translucent, allowing the light to pass through and the images to be seen from both sides of the paper.

In production the paper is kept rolled and elevated on either side of the 32 x 22in. (81.28 x 55.88cm) heated plate. (Elevation keeps the edge of the plate from marking the paper.) Paula applies encaustic colour to the heated metal plate and begins printing at one end of a long scroll. Over the heated encaustic, she places petals from artificial silk flowers, lays the paper on top and prints by pressing with the barin. The cloth flowers act initially to block the transfer of coloured wax to the paper, leaving the outer shape of the flowers and a white interior.

Paula removes the flowers carefully so their ghost image is not disturbed. She then rolls the paper to the next area to be printed, and prints the ghost image. She then rolls the paper back to the printing area and reuses the silk flowers which have absorbed coloured wax from the initial printing. She lays the flowers on the plate and they transfer their encaustic to the paper, similar

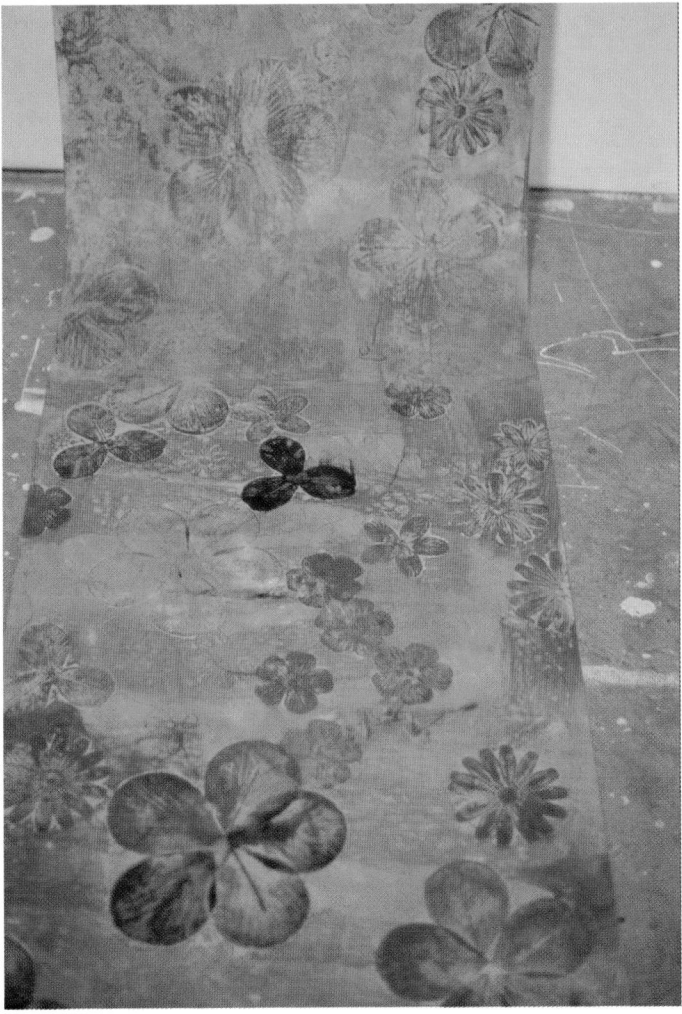

Chant (Detail), Paula Roland, 2003, encaustic monoprint and fabric flowers stamping on Japanese paper. Dimensions variable.

to a stamping process. The background colours become increasingly lighter in each printing until all the encaustic has been used.

She then applies pure beeswax on encaustic medium to the heated plate and lays the paper in the wax to absorb it and make the paper translucent. In the mid portions of the long scrolls that were not printed with flowers, she draws into the translucent waxed paper with charcoal or graphite. When it cools, the wax fixes the drawing to the paper. The far end of the scroll is again printed using the silk flowers which have absorbed encaustic colour. In the end, the paper that was initially white is either waxed and made translucent, or printed with coloured wax.

Alexia Tala (UK – Chile): Encaustic monoprints

Untitled, Alexia Tala, encaustic monoprint adding extra pigment powder on Kozo paper 18 x 15in. / 45 x 37cm.

Alexia is a Chilean artist who lives and works both in London, UK, and Chile. This piece is part of an experiment using drying encaustic sticks, using the same technique as the previous artist, with heat but adding more pigment in order to get a more textured print. She does this by drawing several times with the pigment stick and recovering the dried up pigment left on the plate.

This monotype was a onetime drawing and was printed all at once, using sticks made out of encaustic medium and metallic pigments on kozo paper.

In order to get metallic colours the artist mixed the encaustic medium with pigments that contain mica powders or with plain colour pigments and added mica powder to it. There are also transference pigments which, depending on the light, reflect two different colours; they can also be mixed with the encaustic medium to create sticks, and the result is a print that changes colour..

Susie Thomas Ranager (USA): Encaustic monoprints and rubber stamps

Susie works in different media, also using encaustic monoprints.

The faces in the piece below were randomly placed using rubber stamps and a jet black archival ink stamp pad. The outlines of the figures were then drawn around the faces with a 2B pencil. The large square at the top was produced by the encaustic printing method of lightly pressing the paper with a barin on a heated metal plate in which a design had been drawn until it transferred to the paper. The solid black areas were brushed freehand using black India ink. The gold areas were produced by dipping a brush in melted wax containing a substantial amount of gold pigment, and then brushed in place.

Susie used unprimed 280gm Rives BFK paper for this print.

To make a print like Susie's using only printing techniques rather than hand painting, the faces could have been drawn on the paper, and then the background drawn on the anodised aluminum plate. Stencils of newsprint could have been placed on the faces, so they didn't get any ink on them.

The tribe, Susie Thomas Ranager, rubber stamp and encaustic monoprint on paper. 27 x 33in. / 68.5 x 84cm.

MIXING PRINT TECHNIQUES AND ENCAUSTIC

MIXING PRINT TECHNIQUES AND ENCAUSTIC

Cynthia Winika (USA): Fireworks and wax

Cynthia lives and works in New York. She is an exhibiting artist and also works extensively in educational programs running encaustic workshops at R&F, a company which manufactures encaustic paints in New York.

The pictures shown are part of a body of work exploring the theme of memory of past places and lives.

They reference two years that she spent living in China, as well as concerns she had at that time, and show how this type of exploration can affect one's ways of working. Just as life tends toward complexity and flux, she finds herself pulled toward methods that involve a certain amount of chaos.

These pieces began with the exciting and chaotic process of exploding fireworks on large sheets of paper, leaving calligraphic burn marks and traces of gunpowder, smoke and colourful chemistry. These were then collaged with related elements from the past and present, including landscape paintings from the time she studied in Hsin Pei Tou, figure paintings done recently in the manner of Chinese-style painting, and old Chinese calligraphic poetry expressing timeless sentiments. These fragments of different places and times were then integrated and encapsulated in beeswax medium to form luminous, multi-layered collages.

Chinese Galaxy, Cynthia Winika, 2000, 38 × 50in / 96.5 × 127cm., encaustic, gunpowder print from fireworks explosion, Xerox transfer, joss paper, on Stonehenge paper.

These were waxed from underneath mainly, with a little extra waxing from above.

Cynthia used two palettes placed next to one another, and brushed large quantities of medium onto them, then laid the paper directly on to them. The wax fuses from underneath, permeating the paper. She added some thin Asian paper from the front with watercolour paintings on them, waxing it in a collage style.

The medium had to be applied to the palettes many times, placing the paper down into it in new spots until the whole huge sheet was permeated and fused with wax.

The gunpowder was added first to the bare paper by setting off Chinese fireworks on the paper, letting it burn in and through in certain places.

The charred areas and loose chemicals are encapsulated in

Eclipse, Cynthia Winika, 2000, 38 × 50in. / 96.5 × 127 cm, Encaustic, gunpowder print from fireworks explosion, watercolour paintings, joss paper, Xerox transfer on Stonehenge paper.

wax. The green and brown splotches are the colour of the various chemicals in the fireworks which were emitted when they went off.

The calligraphy was transferred from Xerox prints onto the back of the paper or directly on the front.

'The thing I really like about these big pieces is that they can be rolled loosely in a box between waxed paper and foam paper for shipping and they don't take up much space. When they are unrolled and hung the curl comes out within a day or so in room temperature. (Must be rolled and unrolled at room temperature).'

■ 1.2 PRINTING NON ART MATERIALS

There are no limits to experimenting. Several contemporary artists use techniques to adhere different non ink materials to their prints: for example, Peter Blake has used diamond powder, Finlay Taylor has used flocking and dead butterflies, and Kelley Walker has used dark and white chocolate instead of ink for silkscreen.

Others print on non art materials, such as Elizabeth Peer, who prints on lead, or David Rhys Jones, who prints on ceramic.

Agathe Sorel (UK – Bulgaria): Making objects and printing sand

Agathe Sorel has lived and worked in London for the past 51 years.

She won the Gulbenkian scholarship between 1958 and 1960 to work with S. W. Hayter at the Atelier 17 in Paris.

She was one of the first artists to experiment with making objects and sculptures using print techniques. Most of her sculpture is engineered Perspex, some with welded steel armature. Both hand and machine engraving is used.

Agathe made an artist's book *The Book of Sand*, which was a collaboration with poet David Gascoyne. It is a mixture of poetry and printed drawings.

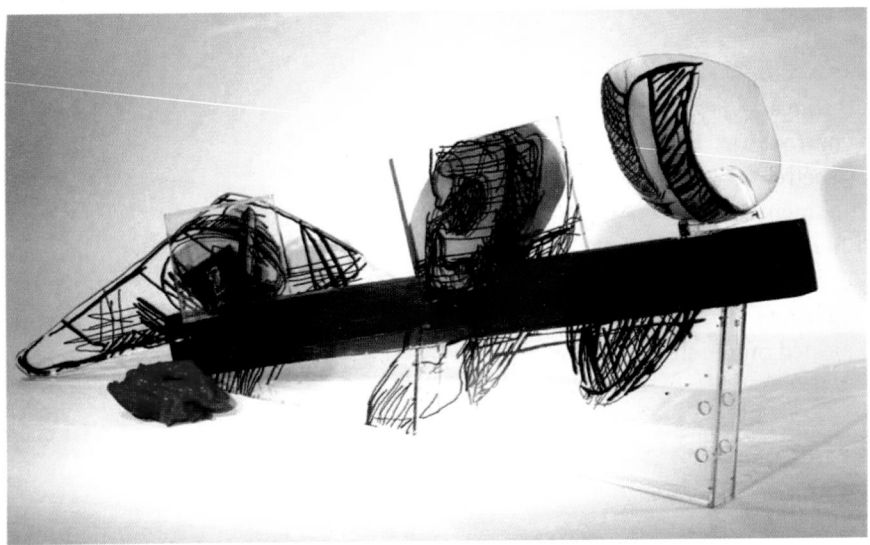

The Lure of Lost Culture, Agathe Sorel, (1982) timber balanced on two pieces of upright Perspex with slotted slabs of Perspex (including embedded found object) and curved sphere, engraved and sprayed with yellow, pink, and silver acrylic, flanked by red coil shape. 86.5 × 49 × 27.5in. / 220 × 124 × 70 cm.

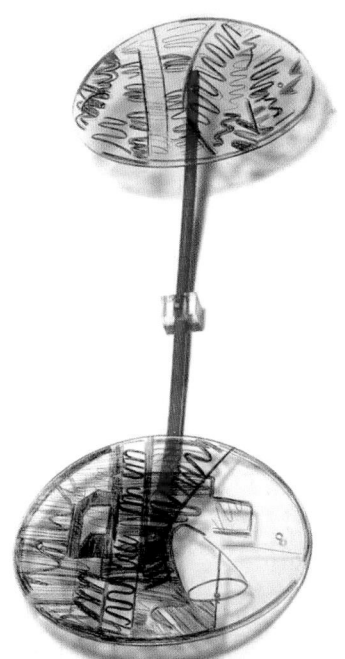

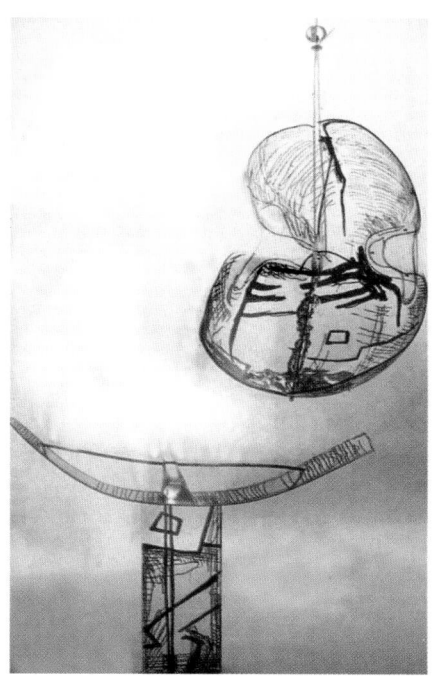

Samurai, Agathe Sorel, (1969) Perspex: two ovals attached to solid acrylic red rod; hand engraved in black and green. 52 × 21.5 × 10in. / 132 × 55 × 25 cm.

Oyster, Agathe Sorel, (1983) Perspex: transparent wall hanging with accompanying lower structure; part of a sphere cradling injection moulded pieces, arched shape below with rod, balanced on upright slab on a double translucent brown base, all hand engraved in turquoise, blue and black, topped by an egg shape containing tiny transformers. 86.5 × 49 × 27.5in. / 220 × 124× 70 cm.

She discovered the beauty of children's drawings on sand at the beach in Lanzarote and did a series of studies 12 metres long, which she documented by photographing from different places, from the bay, and the sky from aeroplanes.

The process of raking sand was repeated on the sheets of acetate interleaving the prints, which keeps the translucency of the page underneath, providing layers of images and information. The patterns were printed on it with silkscreen varnish. Sand in three different colours was dusted onto the varnish, which was raked with a comb. Gold leaf was used for highlights.

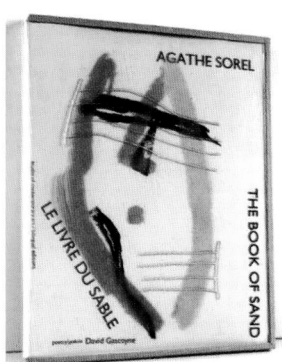

The Book of Sand, Agathe Sorel, 2001, digital montage and silkscreen. 13.5 × 11in. / 34 × 28 cm.

The Book of Sand, (interior pages) Agathe Sorel, 2001, digital montage and silkscreen. 13.5 × 11in. / 34 × 28cm. This is a limited edition Artist's Book of 100 copies, composed of 13 full page prints, interleaved with acetate pages printed with sand.

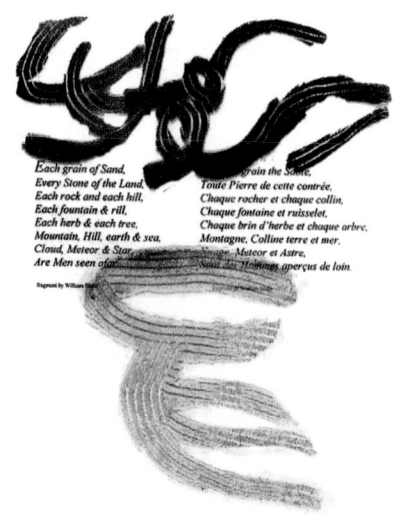

The photographs of raked figures were enlarged with a photocopier and collaged, allowing a few drawn lines only for emphasis so as not to distract from the reality and authenticity of the subject. The whole montage was then printed with a large digital press.

Alexia Tala (UK – Chile): Printing sand and adding encaustic

Alexia is a Chilean artist whose practice spans different disciplines.

During her MA studies at Camberwell College of Arts, London, she was determined to challenge the flatness of the paper, trying different techniques, like collagraph, carborundum, flocking, encaustic print, etc., intending to build a sculptural relief on a traditional flat surface. Trying to develop tactile results on prints was one of her main interests.

She was lucky enough to work with the same technician that Agathe Sorel worked with many years before, Stuart Murrow, and with his advice and the sponsorship from a screenprinting company, she started experimenting with how to print sand by using silkscreen and printing different types of varnish. The one that worked best was the slow drying varnish, Marler gloss.

Steps:
- Make a stencil and coat it on the screen.
- Print image with Marler gloss slow drying varnish; it is very sticky and acts as an adhesive.
- Immediately sprinkle on the sand or flocking you want.
- Put the print aside to dry with the sand on it for ten minutes.
- After ten minutes you can shake the print, and only the areas with varnish will hold it.
- Put it on the rack to dry for at least 24 hours.

Intimate Immensities series relates to Intimate Immensities Installation (see page 62), Alexia Tala, 2003, monoprint, silkscreen and added encaustic medium on Somerset paper. 24 x 24in./ 60 x 60cm.

PRINTING NON ART MATERIALS

Intimate Immensities series, Alexia Tala, 2003, monoprint, silkscreen and added encaustic medium on Somerset paper. 24 x 24in./ 60 x 60cm. This series was done using the flocking printing technique and adding two layers of encaustic medium on top.

It is important to do this process with an assistant; one person should be printing on the screenprint bed and the other person should sprinkle the sand. While this is happening, the printer should carry on printing on newsprint and not stop until the next print gets to the printing bed, or the varnish will start drying on the screen and will damage the image as well as the screen.

The steps added were:

- Put masking tape all around the edge of the print, not a very sticky one so it is easy to remove later without damaging the paper.
- Add two layers of encaustic medium to the printed surface.
- Add pigment mixed with white spirit and brush it on top quickly.
- Then clean the whole print with a cloth and linseed oil or white spirit.
- Remove masking tape.

The layers of wax will never be even because of the texture of the sand, so parts of it won't get encapsulated by wax. Those areas will darken when applying the pigment layer and the rest which is covered in wax will clean away.

David Rhys Jones (UK): Printing on ceramics

David is an MA graduate from Central Saint Martins College of Arts.

David's work draws inspiration from Charles Baudelaire's concept of the 'flâneur', as a detached observer of the modern metropolis. The process for his work involves walking, taking journeys and recording them using photography and drawing.

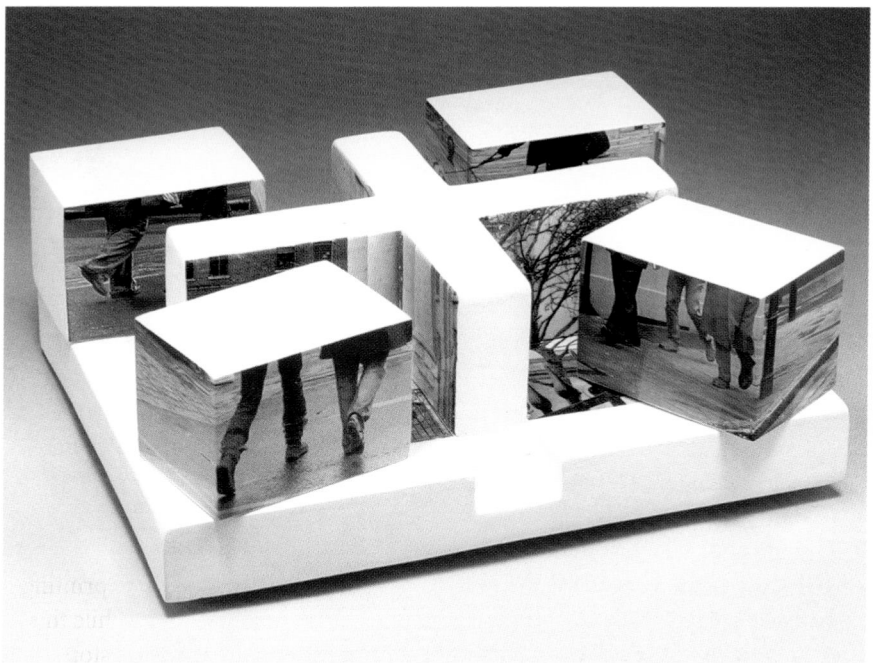

Cross, David Rhys Jones, 2006, five separate pieces arranged, photographic imagery printed onto ceramic. Overall dimensions 10 × 10 × 3.6in. / 12.5 × 10 × 4.8cm.

PRINTING NON ART MATERIALS

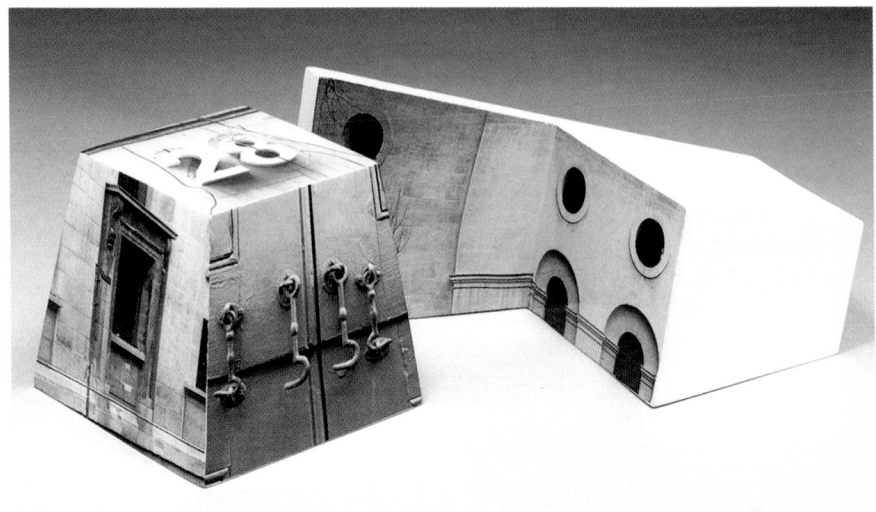

Shift 1, David Rhys Jones, 2006, two separate pieces arranged, photographic imagery transferred onto ceramic. Overall dimensions 10 × 10 × 3.6in. / 12.5 × 10 × 4.8cm.

He creates sculptural forms inspired by the architecture that he has seen during the walk; these forms are then worked on, transferring the images collected onto the ceramic moulds to provide, as David says, 'a sense of place', making narrative work that reflects the experience of the journey.

His work is constantly dealing with social issues, providing a social documentary and recording the mix of architecture and cultures and the way they co-exist in an ever changing world.

The works shown above, *Cross* and *Shift*, were the result of a walk through the Spitalfields area in east London.

Most of his work is photographic imagery printed onto ceramics.

Steps:
- The ceramic forms are made using moulds to allow for a small limited edition of sculptures to be made. The slip-cast forms are produced using a liquid casting slip in plaster moulds.
- Once dry, the forms are released from the mould and when quite dry are fired to a temperature of 1120°C (2048°F).
- A glaze is applied to the form where the image is required.
- Fire for a second time at 1000°C (1832°F).
- The work is then ready for the printed imagery to be applied using digital ceramic decals.
- A final firing takes place at 830°C (1526°F) to fuse the image permanently to the glaze.

Elizabeth Peer (UK): Printing on lead

The main issue tackled by Elizabeth's practice is memory; she investigates how we retrieve memory and what it means. Most of her work starts from family photos, such as the lead print series, as well as installations she has done in the past as *Left Luggage*, where she silkscreened photographs onto broken mirrors and placed them in an old leather suitcase with sound, or some of her prints on glass or Japanese paper made into a lantern installation titled *Lanterns Encased*.

Through seeing her work, the viewer would recall their own experience, examine buried layers and hidden fragments and have sudden insights into things forgotten. The reaction provoked in the viewer by the work is as important as the artist's inspiration and original concept for the piece.

"Family photo albums record both preservation and decay, lies and truth."

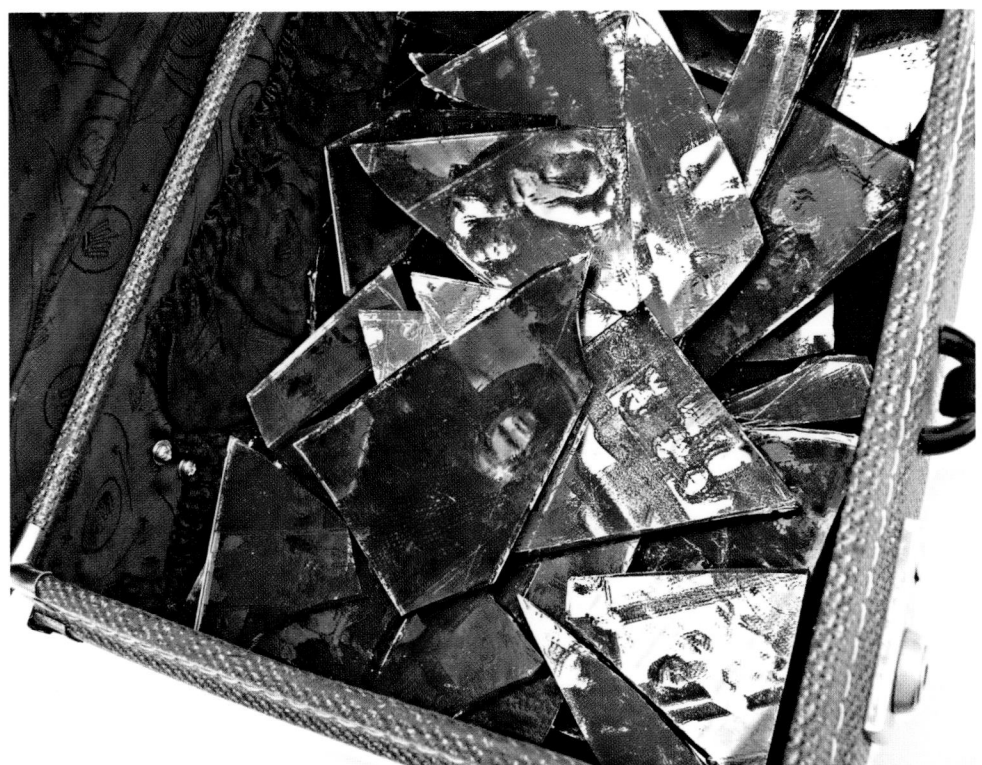

Left Luggage, Elizabeth Peer, 2005, Sound piece: suitcase, photo fragments silkscreened on broken mirror and children voices. 16 × 12 × 5.5in. / 40 × 30 × 14 cm.

Freeze (detail), Elizabeth Peer, 1998.

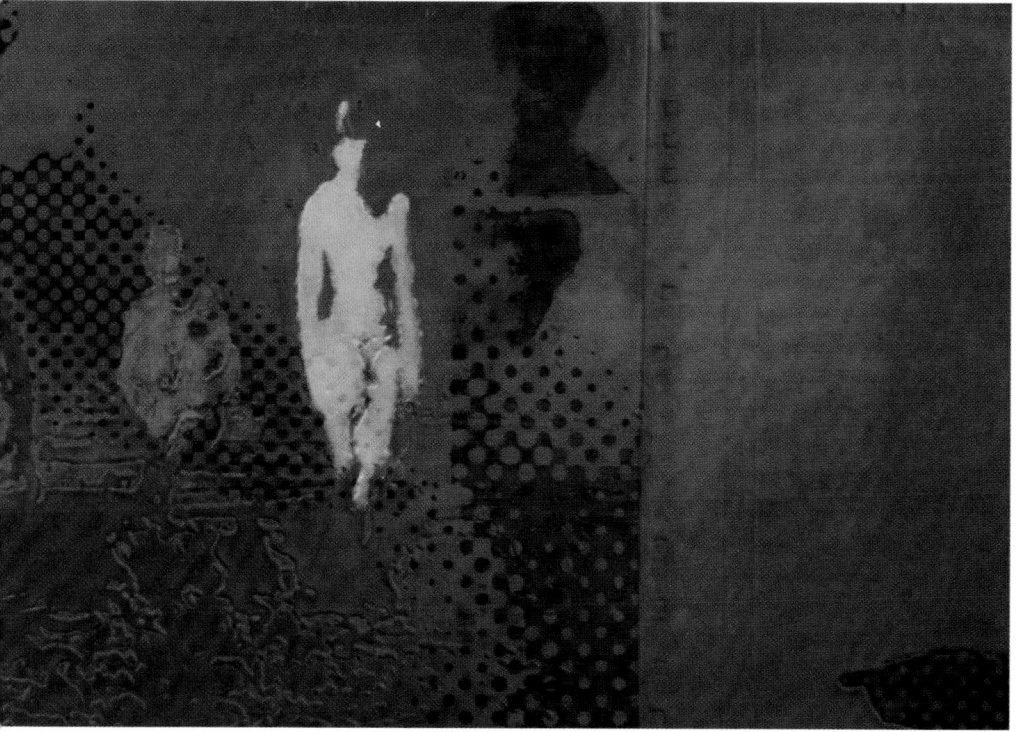

Freeze, Elizabeth Peer, 1998, embossed lead with pigments on plywood backing, 36 x 18in. / 91 x 46cm.

Elizabeth has experimented widely with lead; she uses it instead of paper.

Steps:

- Cut a piece of lead from the roll. It comes in different thickness. The artist uses 0.5mm, which she purchases from builders' merchants. It is easy to cut and manipulate and it responds well to various surface treatments.
- Degrease the lead with either white spirit or methylated spirit.
- Prepare the surface with metal polish such as Brasso™, Silvo™, Zebo™ or any other you wish to experiment with.
- Cut templates or any relief or texture you would like to get and place them on the press bed underneath the prepared lead sheet. Make sure you cut several templates if you are making an edition, so you are able to keep the template underneath the embossed image in order to strengthen it.
- Roll it through the press and you will get all blind embosses from the templates or textures showing.
- Adding images to the surface, such as photocopy transfers, can be done by placing the photocopy face down onto the lead and rubbing on the back of it with a wet cloth with screenwash. Elizabeth has tried many and feels that Sericol™ screenwash works better.

PRINTING NON ART MATERIALS

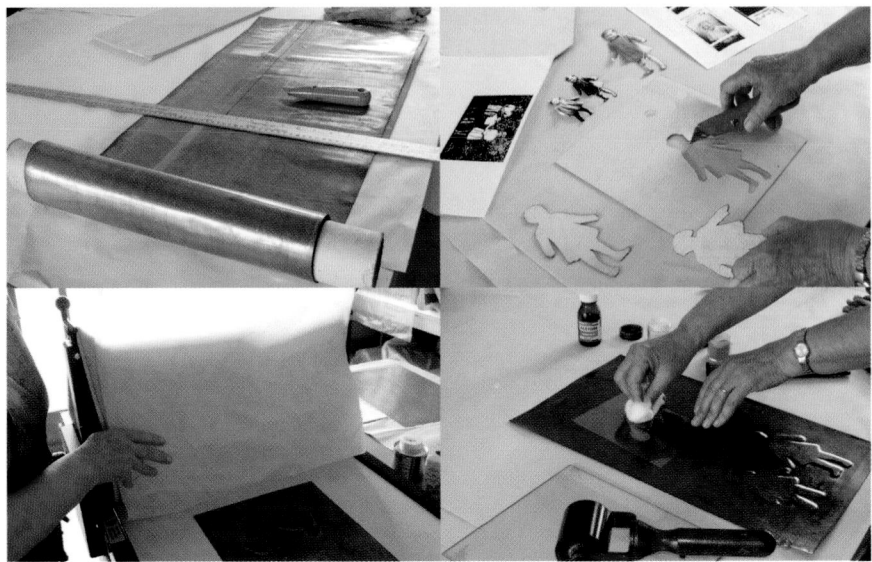

Stages of printing on lead process.
See page 29 and 30 for full process description.
Materials: lead, templates, pigments, inks, roller, printing press.

- Lazertran™ waterslide decal for inkjet printers is another way to transfer images; the big difference between Lazertran™ and phototransfer is that with Lazertran™ the image doesn't get transferred but sits on the surface.
- Ink can be rolled up on the embossed images and when the ink is still wet it can be dusted with metallic powders.
- Lead is fragile creases easily; the finishing recommendation would be to use plywood or MDF, keeping the template underneath and gluing it to the wood with impact adhesive.

CAUTION: there are serious issues to be aware of when working with both lead and screenwash.

Wear gloves at all times when handling the lead and wear a mask. If possible, use an extractor fan when using the screenwash. If this is not possible, make sure you are in a well-ventilated room.

■ 1.3 ETCHING PLATES AS ARTWORK

It is usual to hear artists say that the actual plate looks much nicer than the prints, especially when using collagraphs. Some artists have crossed the boundary of convention and used the actual plates as the artwork itself. There are so many examples, but some dramatically different ones are talked about in this chapter, such as Rebecca Gouldson using metal plates and patinas, etching the plate and covering it with enamel, or using non-traditional materials such as polystyrene as a printmaking plate.

In other words, these artists have stopped using the plate as a medium to print the work on paper, and use it as the print itself.

Rebecca Gouldson (UK): Etched metal plates as artwork

The ideas in Rebecca's work stem from the built environment, in particular from scarred and eroded architectural facades: peeling wallpaper revealing patterns of mould, the remains of a staircase on a half-demolished building, protruding pipes and electricity wires.

Using etching techniques, she creates metal wall pieces with richly textured surfaces; drawing into and onto the surface of metal with a palate of acid-etching and patination techniques.

Pieces are constructed from sheets of gilding metal. Gilding metal is an alloy of copper and zinc. The zinc content strengthens the metal whilst maintaining the colour properties of copper, including its ability to be patinated with chemical and heat treatments.

The surface of the form is etched using ferric chloride solution, which is favorable to nitric acid as it doesn't lift off the delicate resist as quickly and is easier to work with.

Rebecca uses two main different etch resists: paint-on black stop out (sometimes called black polish) and Lazertran™ (a transfer paper which is put through a laser copier, and then used as a waterslide decal to slide onto the metal, then baked on). The ink from the copier acts as the resist. She has also used more traditional printmaking resists such as hard ground, and more unconventional ones such as nail polish. There are times when she uses both forms on the same piece.

Using Lazertran™ means that she can transfer photocopied images, drawings and monoprints she has made on paper onto the metal.

When the piece has already been etched, it is cleaned up and then silverplated.

Once the artwork has been silverplated, the piece has a chemical patina applied, called potassium sulphide, which turns the whole surface from dark grey to black.

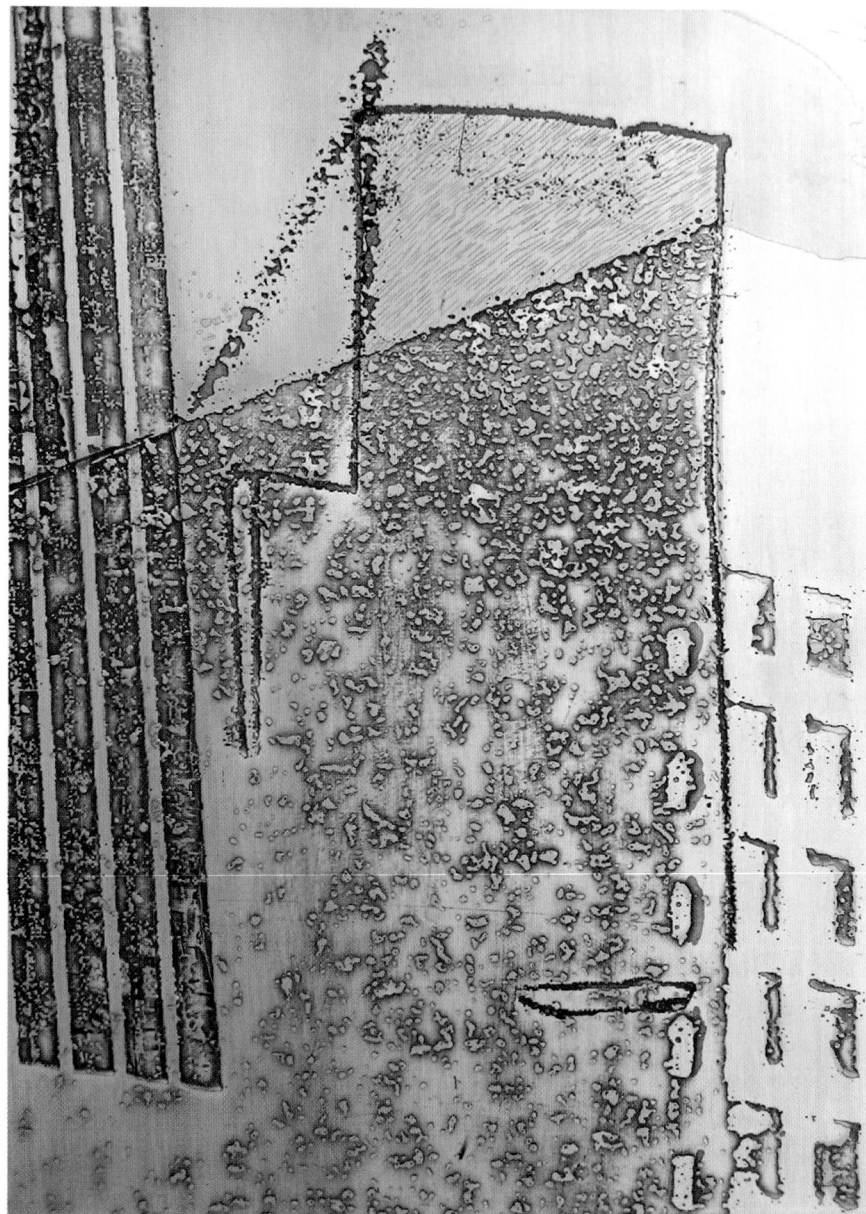

Triptych 1 (detail), 2007, Rebecca Gouldson, etched and patinated gilding metal.

She then uses an abrasive paper to sand back through the layers of patination and plating to reveal both silver and gilding metal surfaces. The etched pattern is accentuated by this process.

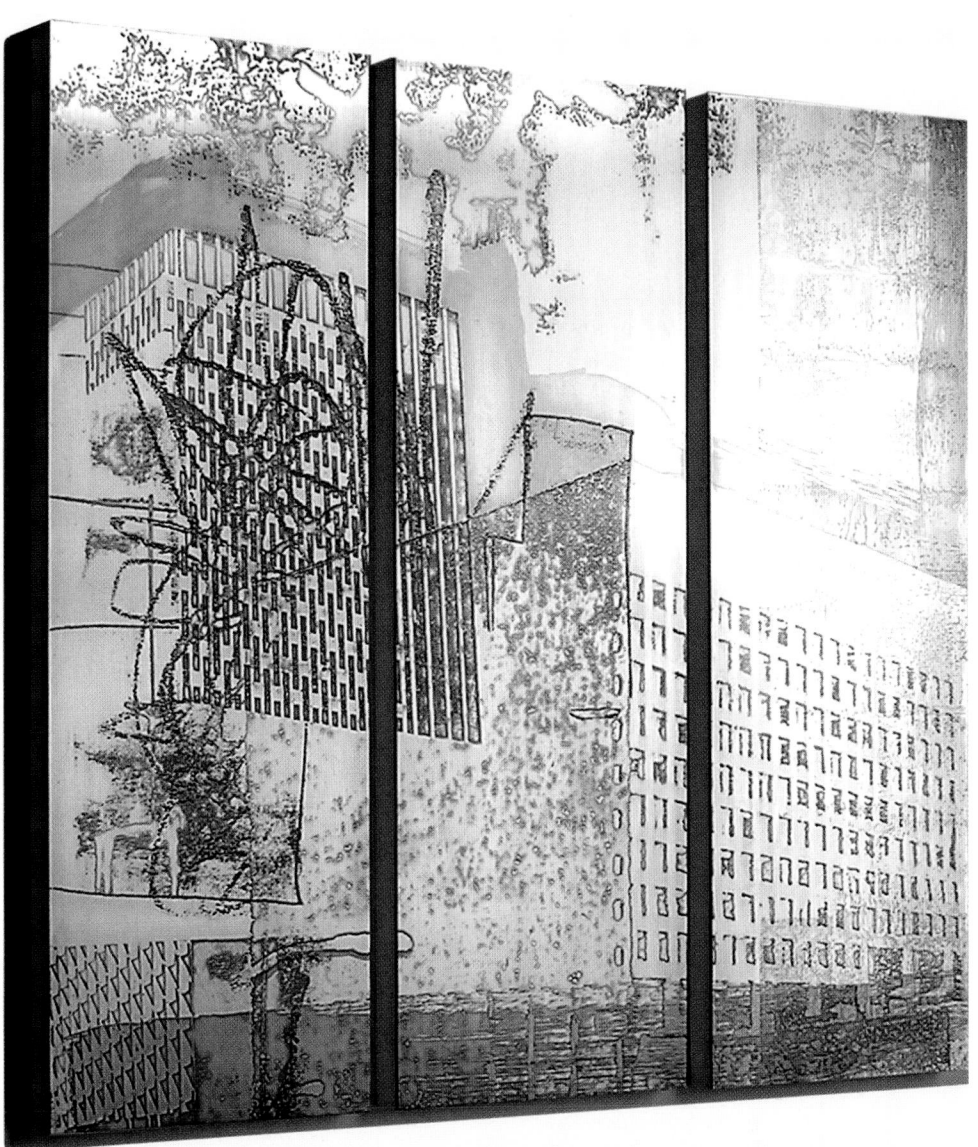

Triptych, Rebecca Gouldson, 2007, etched and patinated gilding metal, three panels.
6.3 x 19 x 0.8in. / 16 x 48 x 2cm each

Daniel Alcalá (UK): Etched plates and enamel

The work of Daniel Alcalá is another good example of artists using the plates as artwork; he takes us beyond the pure practice of cartographic representation of places that he chooses as a means of visual expression in his practice.

Throughout his work, the concepts of 'the urban' and' transit' have been interpreted as a metaphor for the human need to encounter a better place to live.

The artist uses city maps as a starting point for his work and, through his artistic language, reduces their urban origins to their minimum formal expression. This results in highly abstract maps which are separated from any original sense, allowing the viewer to find their own conceptual and aesthetic significance.

Daniel works very meticulously on the map series. He tries to recreate his experience of those places, by converting the act of creating these maps into mental transits, as an imaginary walk through those streets.

The inspiration for these works came to him when he was working on his cut paper maps.

'I wanted to create new works using printmaking in order to give this series a continuation on this area. My idea since the beginning was to create works that will keep the idea of cutting without having a similar result as a work on paper. I didn't want the prints to resemble my earlier map works, I always thought about having pieces that will take me in new directions, exploiting the technique to its limits.'

The idea of these works began with the concept of having the copper plate as the work.

He thought of using traditional printmaking techniques on the plate to trace the images of the maps, keeping in mind that he wanted to cut the pieces as he does on paper. In order to obtain the cuts on the metal plate, he uses acid; by etching the copper plates for a long period of time, the plates could be cut out. The length of time spent etching the plate with the acid depends on the concentration of the acid.

Having cut the plate, he tried different methods of display. He discovered that by hanging it against light and spaced a few centimeters from the wall, the reflected shadow was actually the imprint of the work on the wall. The wall acts as the support of the piece, and the plate, created using a traditional print-making technique, stands as the work.

The last issue that needed solving was how to make editions of the work. This was achieved by 'copying' the image of one plate to the other using the transfer technique.

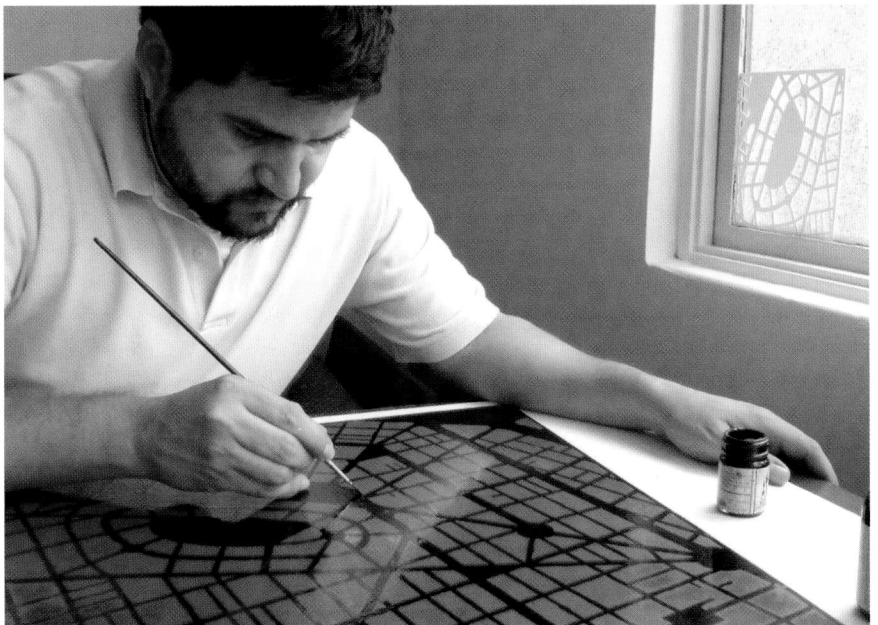

Daniel Alcalá, the artist working on the copper plate painting the negative of the map using stop out varnish.

Steps:

- Trace the map on the varnished plate.
- Put the plate on the acid. When the acid attacks the plate, the lines traced become clearer.
- Block the image with varnish.
- Transfer the image to the other plates.
- Block the rest of the plates with varnish.
- Put them into the acid until it cuts the places where the image is not traced.
- Sand all edges and spray-paint with enamel.

Mapas – (ciudad de Mexico) – Maps (Mexico city), triptych, Daniel Alcalá, 2007, etched cooper plates painted white. Edition of 5, 19 × 19in./ 48 × 48cm each.

ETCHING PLATES AS ARTWORK

Diego Fernández (USA – Chile): Etched polystyrene with spray paint

Diego's work deals with social issues; he is interested in folk sources of oral history and metaphorical constructions which lead to a revision of today's craziness.

His work intends to build oppositions between elements that represent the isolated individual versus political organisation. This is reflected through an arrangement of both found and historical references that expose common-knowledge examples.

This piece is titled *País de Proletas*; it deals with issues of migration. The artist built a wall inside the gallery space as a metaphor for the absurdity of of the wall proposed between the United States and Mexico to stop migration.

The large wall was made by using polystyrene as printing plates on which the artist wrote using a white enamel spray. The spray corroded the surface of the polystyrene having a similar effect to acid on zinc or a knife cutting wood.

He then applied black latex using a hard foam roller, just as a roller would be used on a woodcut. The result is a striking white-out-of-black contrast, emphasising the words.

Diego Fernández: the following sequence shows the artist working on the creation of the site specific installation. Materials: polystyrene, spray paint, roller and latex.

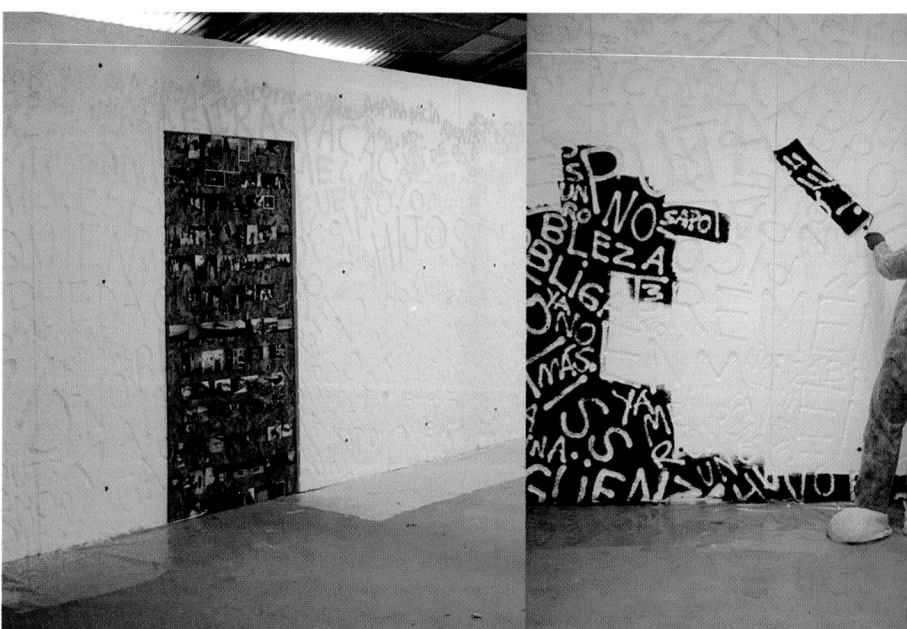

País de Proletas, Diego Fernández, 2007, polystyrene, latex and photographs.
41 × 10 feet / 12.5 × 3m.

ETCHING PLATES AS ARTWORK

Kaori Maki (UK – Japan): Etching Perspex with paint stripper

Kaori graduated with an MA from Camberwell College of Arts, London. Her work focuses on water as a metaphor for universal values.

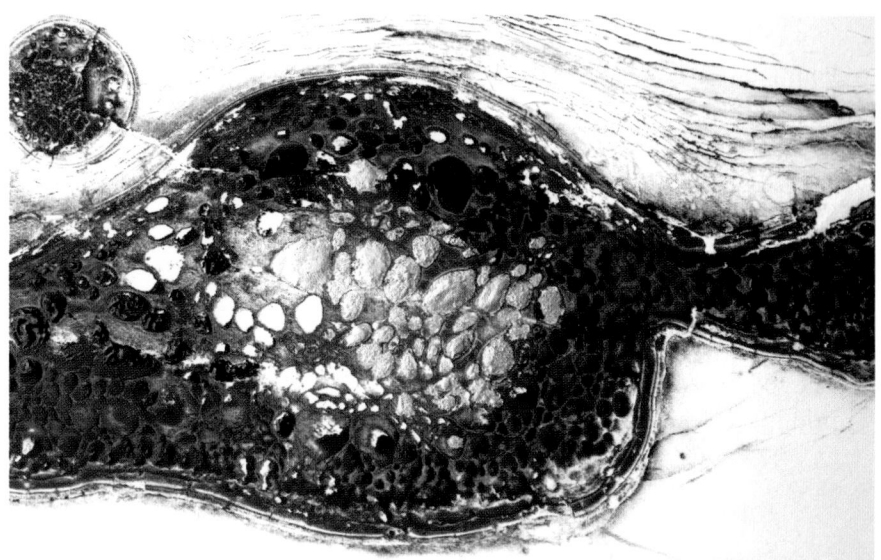

Untitled (detail), Kaori Maki, 2005, print on paper, 23.5 × 23.5in./ 60 × 60cm.

> 'The flowing river never stops and yet the water never stays the same, foam floats upon the pools scattering, re-forming and never lingering long.'
>
> Poem written by Kamono Choumei 1155 – 1216

The concept of flow has a great significance in Kaori's day-to-day journey, while the images that water evokes often remind her of transient human life.

These images connect with the idea that since she was born she has been meeting people. Each meeting holds significance for her path. Her path is like a stream joining together at some points making a big flow or, on other occasions, the flow dividing into separate streams.

> 'When I meet people or experience a moment, I often think of images of water. Thus, although sometimes we do not pay much attention to it, our future is always linked to and somehow ultimately depends on this concept.'

Clearly, many kinds of rhythmical movement can be observed in rivers, in the sea and even by raindrops. Her images are, metaphorically, as fluid as though they themselves are continually forming and reforming into patterns that echo thoughts in our memories.

She has developed a very unusual technique. In a similar way to artist Diego Fernández, who etches polystyrene with spray paint, Kaori etches Perspex by

producing a chemical reaction using paint stripper (paint and varnish remover) as a solvent. In her case she uses the final plate as a printing plate and is able to make small editions before the Perspex gets cracked and damaged.

Steps:
- Dry and smooth the surface of the Perspex plate.
- Pour paint stripper on the plate; metallic or cardboard tools must be used to control the liquid.
- Leave the plate under the sunlight (summer sun) or if necessary use a heat gun or a hair drier. It will start reacting by bubbling with the heat.
- Leave it to dry; it is best to leave it for at least one week.
- Make sure all the bubbles are open; if not, they can be broken by using a needle.
- Wash the plate with cold water; remove slime from the surface.
- Once the plate is ready, the treatment for printing is the same as an etching plate, but the run will not be more than ten copies as Perspex is very fragile. The copies will not be exact copies as the plate will start cracking while printing but that in itself adds to the effect of the print.

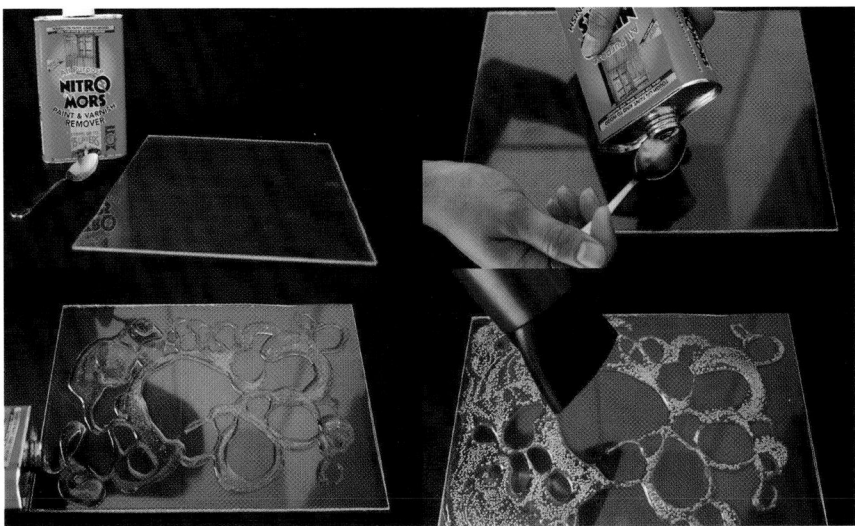

The stages of the etching Perspex with paint stripper process. Materials: paint stripper, Perspex, spoon, hair drier or heat gun.

CAUTION: paint stripper contains Nitromors, dichloromethane (methylene chloride) 80%–90% and methanol 10%–20%. It is harmful and can cause serious irreversible effects. It is toxic if inhaled, if swallowed and if it comes into contact with skin; there is also limited evidence of a carcinogenic effect. It is recommended to work outdoors or in a fume cubboard. Wear a suitable protective fume mask, polythene gloves and safety glasses.

ETCHING PLATES AS ARTWORK

■ 1.4 ADDING IMAGES AND COLLAGING

Other artists take the print as a base which they can add images to, or simply collage different materials, found objects or memorabilia onto. Using the initial print as a background, they are able to portray their ideas and concerns.

Oona Grimes (UK): Adding and collaging non art materials

In Oona's work different media such as drawing, painting and etching collide in order to construct an enigmatic world.

This world is usually inhabited by naked innocents and demonic animations. These characters frenziedly tumble through one another's stories in an almost casual equation of torture and play, nurture and debasement.

> 'For some time I have been working on narrative sequences where the figures float free of landscapes composed of conflicting perspectives and scale. The horrific and the comic, the fact and the fiction co-exist as in a child's colouring or game book.'

Masked out, Oona Grimes, 1998, Etching, collage, spraypaint, *chine collè*. 15 × 146in. / 38 × 371cm.

Masked Out is a sequence of hand-coloured etchings, using hard and soft ground, aquatint and drypoint, wax crayon, acid resist pen and spitbite. After completion Oona adds to the print, spray paint, corn pads, elastoplast and removable objects.

Brenda Hartill (UK): Adding and collaging found objects with encaustic medium

Brenda is a well established artist and printmaker who, after 25 years living and working in London, has recently moved to East Sussex. Her work explores the texture, pattern and light of the landscape.

Her main medium is print, both etching and collagraph, and she creates bold, heavily embossed abstract images. Recently she has become more interested in mixed media collages, which led her into the creation of the *Landrift* series where she embeds fragments of print into encaustic medium and adds found natural materials that she has collected from all over the world.

'I have recently developed an interest in using found natural objects in my prints, using the energy of natural growth patterns, and erosion as a starting point. I am always looking for material for my etchings and collagraphs, and in these unique works I am combining soft ground etching using cactus skeletons, along with the actual plant material. Encaustic wax enabled me to embed these, and also include naturally eroded driftwood pieces, making a complete fused object. As a printmaker, using wax has enabled me to escape the tyranny of the white border, frame and glass.'

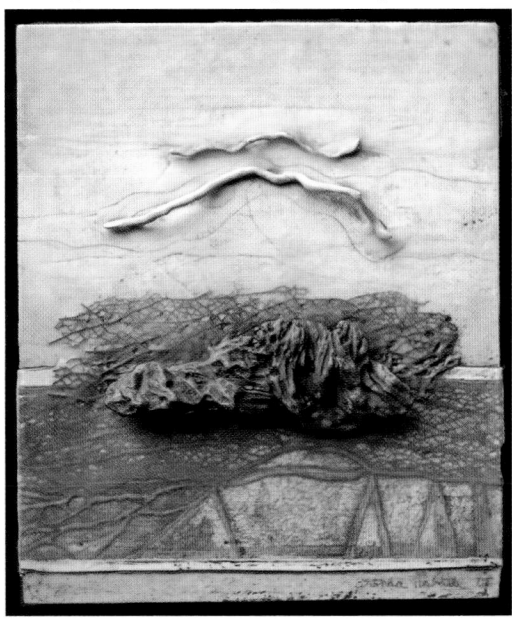

Landrift, 2005, Brenda Hartill, mixed media print, encaustic and found object. 14 × 12in. / 36 × 31cm.

Steps:

- First cut different size pieces of MDF.
- Glue different fragments of prints onto the MDF, making sure the print wraps the edges, so no wood is seen.
- Assemble the different wrapped pieces onto the background.

- Apply two, three or more layers of encaustic medium depending on the desired result.
- Decide where the found objects are going to be placed and glue them by dripping a good amount of wax and pressing the object against it. The wax will dry and hold it.

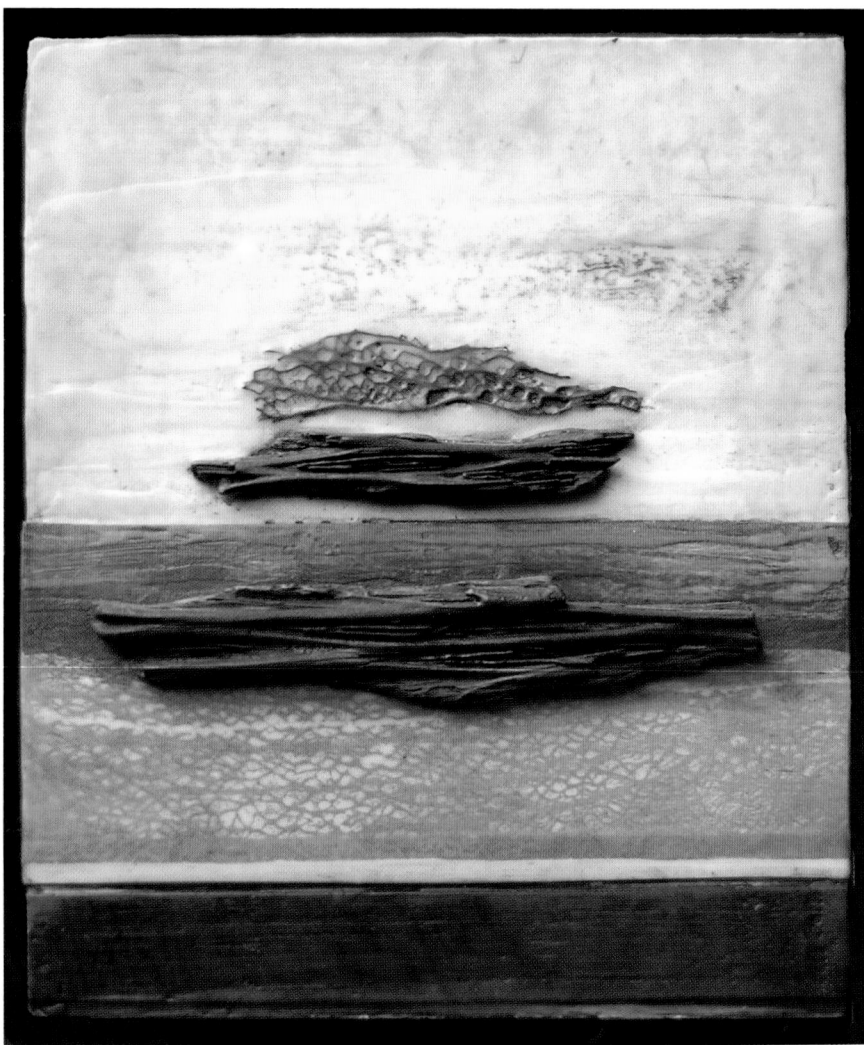

Landrift, Brenda Hartill, 2005, mixed Media print, encaustic and found object. 14 x 12in. / 36 x 31cm

■ 1.5 EXPERIMENTING FURTHER

Janet Curley Cannon (UK – USA): Digital transfers

Janet completed a BA in Art History at the University of Washington, Seattle, USA in 1982. She completed an MA in Printmaking in 2005 at Camberwell College of Arts, London, while also holding an Artist in Residence position at the Digital Media Centre at South Hill Park Arts Centre in Berkshire, UK.

The inspiration for her art comes from urban scenes, surfaces and structures – from the repeated play of familiar patterns to the variation of texture and colour created by shadows, reflections, ageing and decay. She re-creates these scenes and surfaces from photographs and drawings gathered in the course of daily life. Her images use multiple layers to play with opacity, tone and relief elements in order to capture the tactile and visual complexity that is the urban surface. Her work is about the observation of the often overlooked or ignored details all around us in urban life that create their own unique artistic abstractions.

Her work is developed digitally using Adobe Photoshop™ to zoom in, take and crop an image until the core pattern or structure of the work takes shape. She then manipulates and blends further photographs with drawings and scanned textures, using additional digital drawing within the image. As the

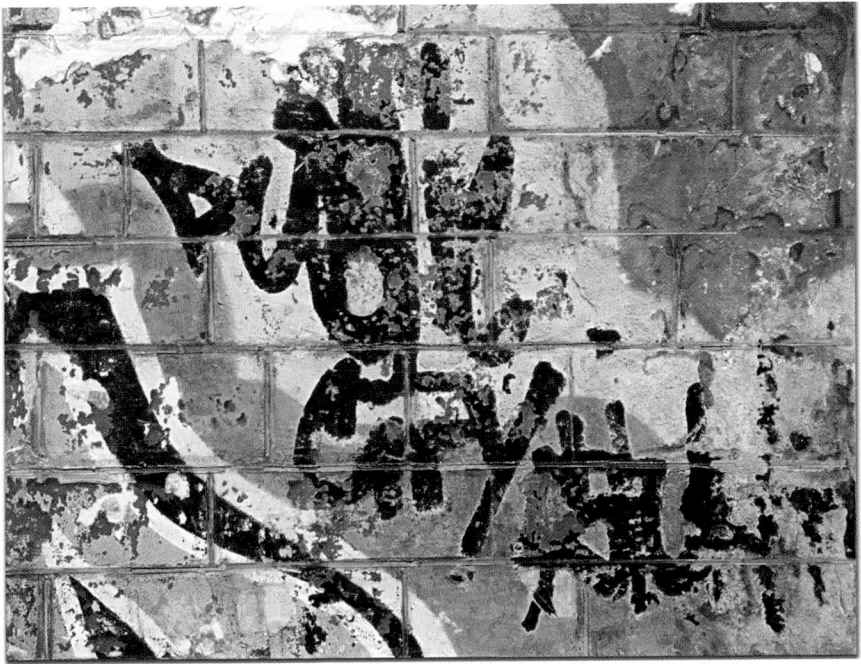

Shoreditch, 2007, Janet Curley Cannon, pigment inkjet transfer and mixed media on fresco on wood panel. 24 × 31.5 × 14in. / 60 × 80 × 3.5cm.

image develops, she'll decide the method and media for the digital print depending on the textural qualities she wants to bring out. Her practice is a 21st century synthesis of traditional fine art materials and the latest in digital print processes.

Shoreditch was created using inkjet transfer onto wet fresco; the inspiration comes from a combination of photos of the graffiti on the back streets of London and is intended to be a slice of the urban environment taken in isolation. The finished digital image is printed onto clear film pre-coated with Inkaid, an inkjet transfer medium, using an Epson 7600 with pigment inks. A wood panel base is prepared to hold freshly mixed fresco which is poured onto the panel and allowed to set. When it is in a firm gelatin state, the film with the image print is laid gently face down and transferred onto the surface of the wet fresco. After a few minutes the film is peeled gently away. While still damp, the fresco can have marks scored across or into it in order to add a low relief textural surface. Once completely dried, the fresco surface has further acrylic mediums, paint, and collaged elements added and then is varnished using a UVLS (UltraViolet Light Stabilisers) acrylic varnish.

The transfer process can be used to add inkjet images onto any surface that will absorb the Inkaid medium, which is water soluble. Using a clear gelatin formula over a low relief surface allows layered images or textured surfaces to be used. The transfer process can also be used on wet unprimed canvas with interesting effects, as in the work titled *Benhill Estate*.

Benhill Estate, 2005, Janet Curley Cannon, inkjet transfer and acrylic on unprimed canvas. 22 x 54 x 2in. / 55.5 x 137 x 3cm.

Cross Over, Janet Curley Cannon, 2006, pigment inkjet print and mixed media on wood panel. 21.5 × 32 × 2in. / 55 × 81 × 5cm.

Cross Over was printed onto Japanese paper and the embossing was made onto a low relief surface.

This piece began with building up low relief surfaces using plaster and acrylic mediums to form the different sections of the wall which sit at different levels above the base. A draft of the image was printed as a simple template first and used to score the cracks into the plaster at the right places. The final digital image was prepared to be printed using pigment inks straight onto uncoated Japanese Shoji 45gsm paper that is lightweight but very strong due to its Kozo fibers. The print was cut to shape and coated on the back with acrylic medium, then gently embossed, using a soft cloth and firm hand pressure, onto the dried textural surface. Further mediums and paints are used in the smaller wall areas and iridescent acrylics are used to create the rust effects. An encaustic surface is added to the left

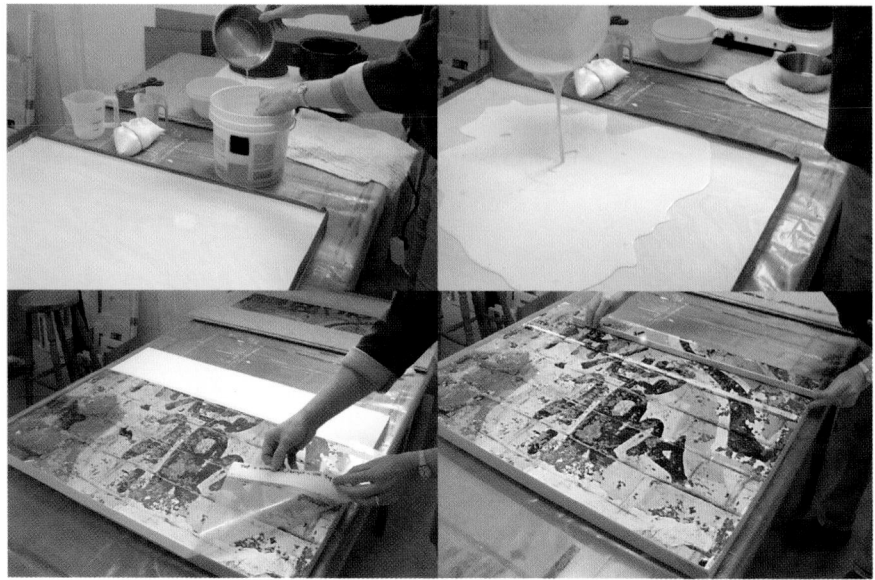

Janet Curley Cannon: stages for pigment inkjet transfer process, showing the creation of the fresco surface and the image transfer.

segment of the wall to give a high gloss but soft effect, while a UVLS matt varnish is used on the rest of the image.

Dan Welden (USA): Exposing plates under the sun

Dan is an artist, educator and master printmaker.

He studied in Europe and is well known for his hybrid works on paper which combine different media such as print, paint and drawing techniques. Most of his work is made by using the Solarplate™ method, a non-toxic technique.

He takes inspiration from the landscape, from patterns of 'sheep tracks' on grassy slopes, forming playful meandering lines and structures.

He has collaborated with and printed for many artists in his own studio, including Willem and Elaine de Kooning, Dan Flavin, Eric Fischl, David Salle and Lynda Benglis. *Printmaking in the Sun* is his latest book, which he co-authored with Pauline Muir.

The Solarplate™ technique consists of drawing onto thin and flexible good quality transparencies; they can be smooth, or textured like True-Grain, which will be reflected in the result on the image. Another way to work is to draw directly onto clear or grained glass.

Photographic images can also be used by photocopying them onto acetate. The image is then placed on a contact frame with the polymer and the

Denver Moment, Dan Welden, 2005, intaglio and relief print using solarplate, printed on German Etching paper. 22 × 30in. / 56 × 76cm.

Solarplate™ and fixed like a sandwich between a piece of MDF and a transparent clean glass with clip spring clamps on each corner. Depending on how sunny the day is and on your images, exposure time can vary from one minute to thirty minutes.

Two plates were made for the creation of *Denver Moment*. The first was an intaglio image, created with pencil on grained glass. The plate was exposed to the drawing and immediately after it was exposed to the screen. It was processed with a normal water wash with a brush. It was printed with 514 Graphic Chemical™ Bone Black ink on German Etching paper.

The second image was created as a relief plate by painting directly on the plate with etching ink. The plate was then exposed and developed with water, washing out completely to the base of the polymer. It was printed on top of the intaglio image with ochre with some transparency and some opaque white ink.

Carolina Furrow was a combination of a vitreograph (glass print) and a Solarplate™ image. The mixed media impression was done with the Solarplate™ relief image as the final impression over several layers of ink printed from glass plates.

Carolina Furrow, Dan Welden, 2006, combined vitreograph (glass print) and Solarplate™. printed on paper. 30 × 22in. / 76 × 56cm.

Jan Hendrix (Netherlands – Mexico): Public commissions

Landscape and everything related to nature is the starting point for most of Jan's work. Nowadays, his work is becoming almost botanical and is paying attention to the smallest details of the big picture, as a zoom into vastness. He sees that technical abilities are merely tools to be used as the shortest way between ideas and works.

He has been printmaking for the last 30 years. His use of print has varied during this time, from film and photography to architecture. He has created many public commissions.

The starting point for Jan are drawings on Mylar®, which are then upscaled or downscaled according to the use: for instance, to smaller (a postal stamp), larger (an etching or a façade), longer (a swimming pool or a courtyard), etc. In the meantime, materials are picked out and tested; anything that is flat, such as glass, paper, steel, wood, zinc, etc. will be considered.

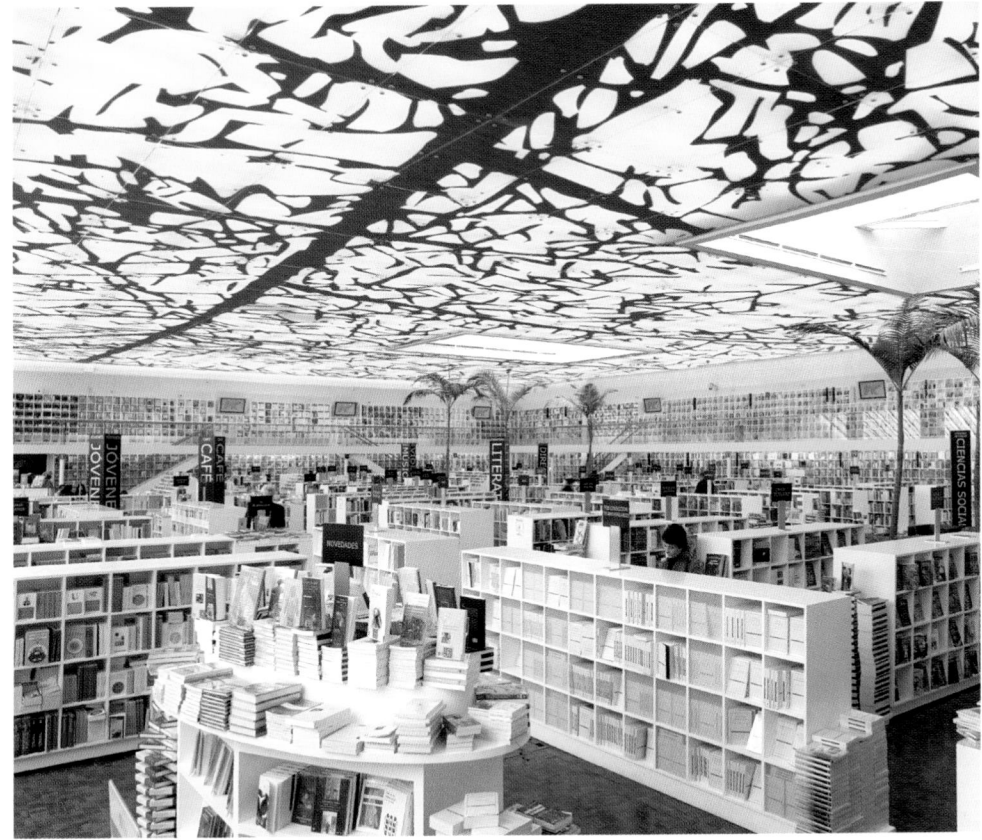

Centro Cultural Bella Epoca, Jan Hendrix, 2006, Silkscreen on 250 crystal panels, 260 × 170cm each, painted with epoxic inks. Site specific work at Centro Cultural Bella Epoca – Mexico.

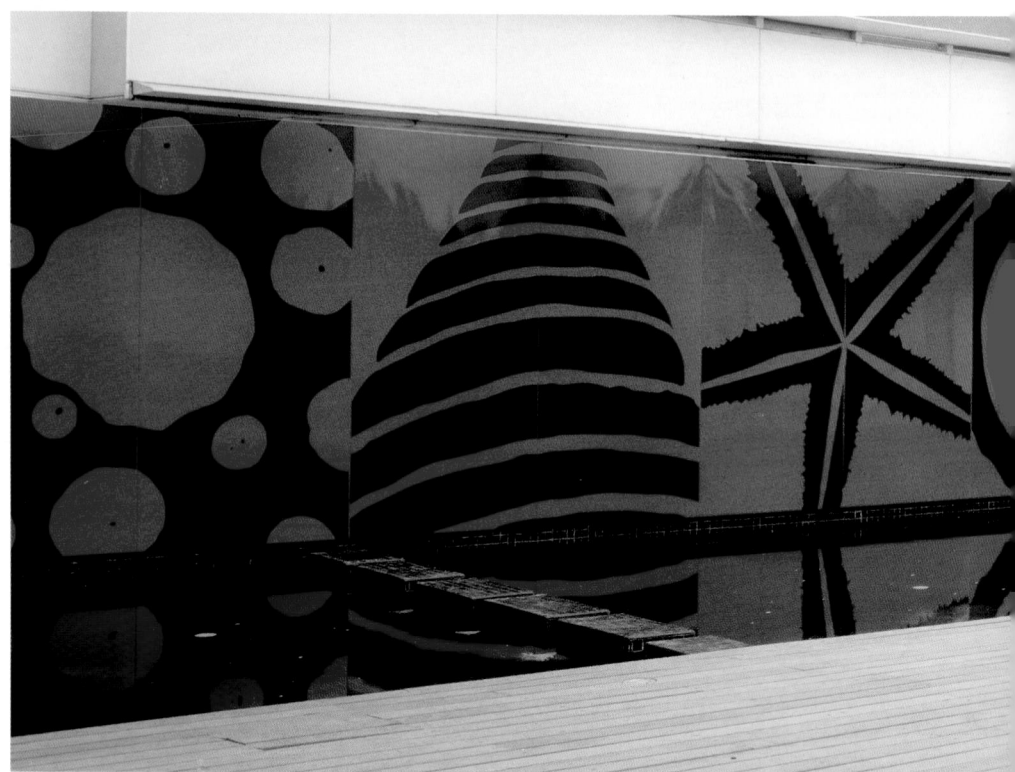

Punta Parque, Jan Hendrix, 2003–2004, silkscreen, porcelain on metal, 24 panels. 1.19 × 2.45m and 4 panels 1.37 × 2.45m. Site specific work at Punta Parque Building – Mexico.

The enamel works are made at a factory in Mexico City that combines the old traditions and handmade process with contemporary technology and a very sophisticated kiln. The glazes are processed at their own laboratory, which enables him to choose from a huge number of options. Having finished one group of works, another series is already in process. Usually a small edition of between two and six, copies is printed and fired.

Jan Hendrix, 2004, printed panel drying process – Mexico.

Jan Hendrix, 2004: silkscreen printing process – Mexico.

Part 2
EXPERIMENTING WITH DISPLAY

■ The second section of this book looks at artists who reject conventional framing and hanging, artists that want to see their work becoming objects and want to see their work spread towards the floor and/or hung from the ceiling and jumping out from the wall.

Display is an essential aspect of artistic work and demands great attention. It aims for the work to become an integral part of its immediate surrounding and the viewer's position changes from being that of an observer to that of a participant.

Many aspects must be included when considering display: the space between work and viewer, the scale of the work in relationship to the viewer; the activation of more senses than just the visual makes the viewer disconnect from the surroundings and experience the installation more directly.

Half-life, Nicola López, 2007, photolitho, woodblock and silkscreen on Mylar.
10 × 24 × 6 feet / 3 × 7.3 × 1.8m.

■ 2.1 INSTALLATION

John Hitchcock (USA): Silkscreen

John is an Artists and Associate Professor from the United States, who lives and works in Madison at the University of Wisconsin. He teaches a wide range of subjects, such as screenprinting, relief cuts, mixed media printing and installation art. His current work depicts personal, cultural, social and political identities.

John feels it is extremely important to examine his community references, both past and present, and contribute to the politics of cultural identity, social issues and visual culture.

He creates an environment of multiple views through mixed media installation, printmaking, assemblage, performance and action; the use of found objects, photographs, paintings, prints, video and music is very much part of his practice.

His multi-media artworks address the notion of sharing ideas through giving away art. Viewers are encouraged to take part in interactive games and receive small hand-printed give-away art pieces and printed objects for participating.

Traditionally, in museum and gallery settings, art is put on a pedestal or framed under glass, removing it from the audience. His approach in his interactive artworks is to bring the art directly to the viewer, to distance his work from this hierarchical standard.

Although he belongs to the academic world, he uses art as a voice to create a dialogue between academic and non-academic communities.

For *They're Moving their Feet — But Nobody's Dancing* John Hitchcock created a print installation in a 24-hour period, printing in the gallery space with the collaboration of students from the Art School of Syracuse University.

The images, which are made up of a repeating pattern of x marks, act as a metaphor for change, cycles, endurance, collaboration and intent. On one level, the repetitive x marks comment on the US government's regional, national and international policies on human beings, on the forcible relocation and removal of people from one location to another.

On another level, this particular piece is a statement about current events, such as the US invasion of Iraq and Afghanistan, the major conflict between the Palestinians and Israelis and the recent announcement by the Johns Hopkins Bloomberg School of Public Health that 'an estimated 655,000 Iraqis have died since 2003' (BBC News).

Ritual Device focuses directly on the consumerist nature of the United States and the impact of its domestic and foreign policies. In his installations, John appropriates the silhouetted logos from United States Department of

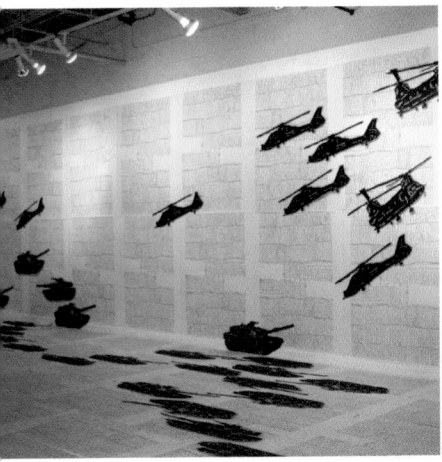
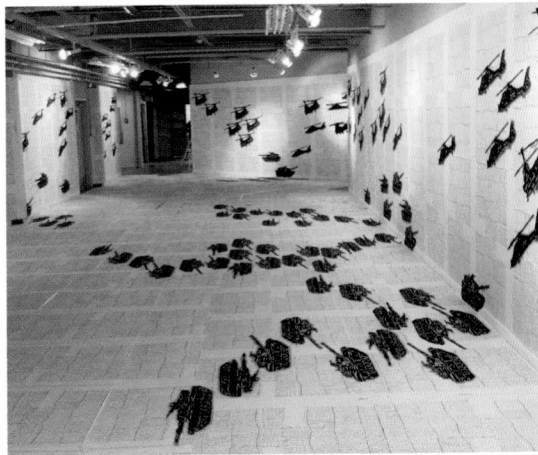

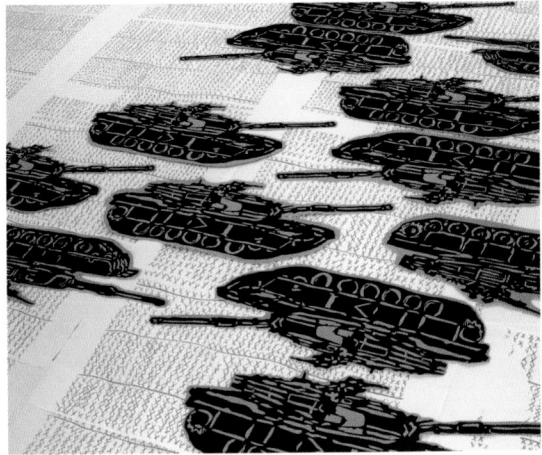

(Above left, above right) *They're Moving their Feet – But Nobody's Dancing,* John Hitchcock, 2007 is a large-scale variable size screenprint action
(Below right) *They're Moving their Feet – But Nobody's Dancing,* (detail) John Hitchcock, 2007

Agriculture commodity food labels (a pig from a can of pork and a chicken from a package of powdered eggs) to question notions of assimilation and control. The commodity foods are distributed by the United States Government for food assistance to indigenous lands, for welfare programs and to third world countries.

> 'These explorations have led me to broader questions about the prolifera-tion of images in popular culture and mass electronic media that inundates our lives daily. What are the societal, psychological, and physiological conse-quences of globalisation? I question the notion of progress, including the influence of technology on society. How has technology affected our people and changed our relationship to our planet? I examine these issues by re-contextualising images from American culture, electronic media, and food to question social and political systems.'

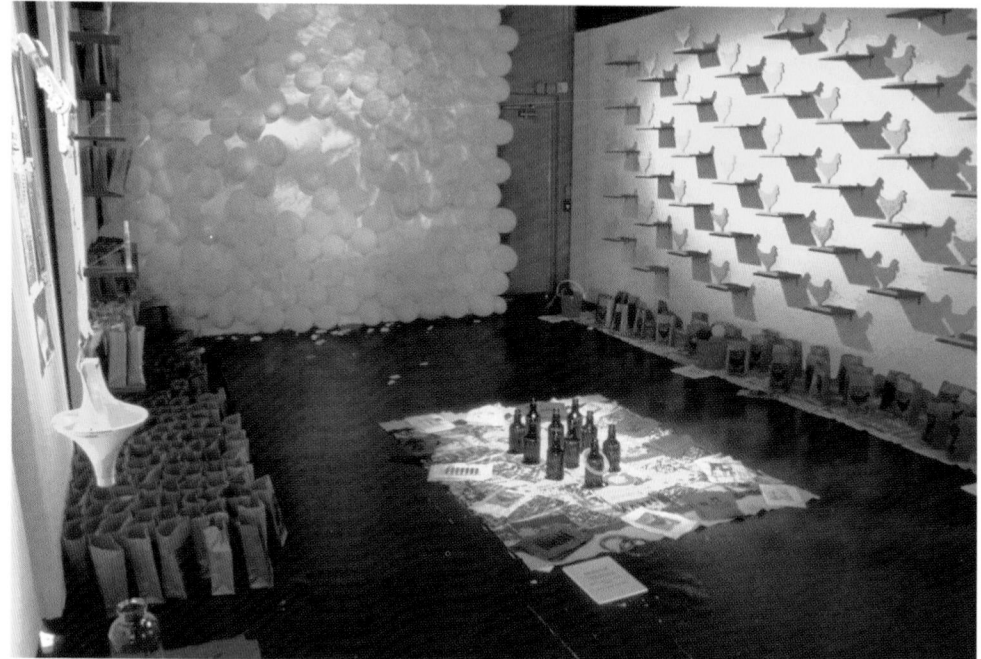

Ritual Device, John Hitchcock, 1999–2006, screen-print, video, sound, objects and give-away prints. Dimension variable.

John grew up close to a military base. 'The memories of helicopters flying overhead, soldiers playing war games in the woods, and tanks noisily driving by at 3am preparing for battles haunt my imagination.'

Ritual Device encourages the audience to toss rings onto bottles. The viewers are also encouraged to throw darts at a wall covered with balloons while video projected images of technology in contemporary America create abstract patterns over the balloons. Viewers receive a printed souvenir for their participation. During the opening, the Give-Aways happen in 30-minute cycles administered by a live performer acting as a carnival barker.

The Give-Aways consist of small felts, paper and objects manipulated with hand-printed ink laid out on the ground below the Dart Game and Give-Away ring toss. After the balloons are popped, the videos continue to project through the exhibition. The sound is a mixture of industrial noise and traditional Native American songs.

The issues explored in *Ritual Device* question Native and non-Native American identity, assimilation, borders, ritual and adaptation.

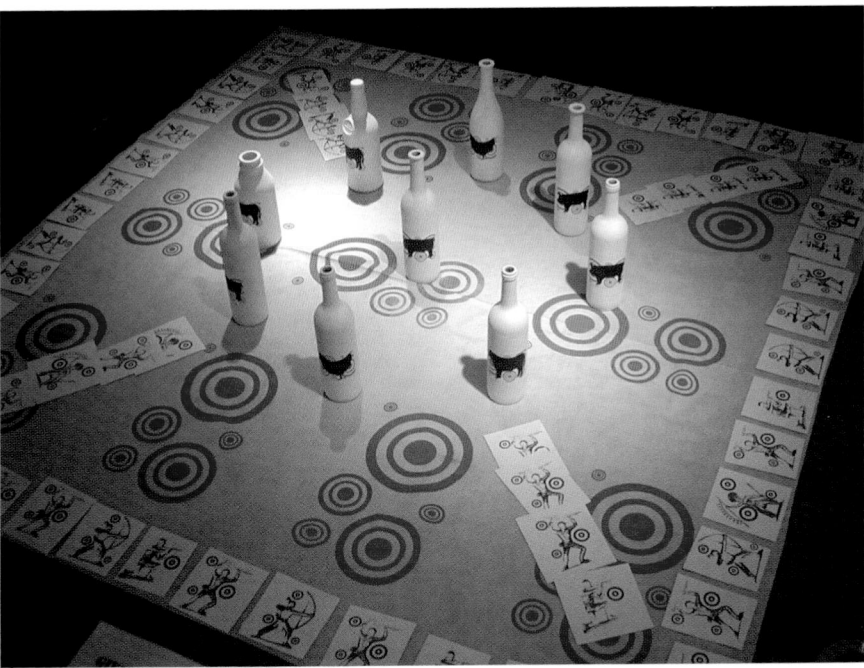

Ritual Device, John Hitchcock, 1999–2006, (Above) Fragments, screen-print, inkjet prints, bottles and give-away prints. Dimension variable. (Below) Public interacting with the artwork.

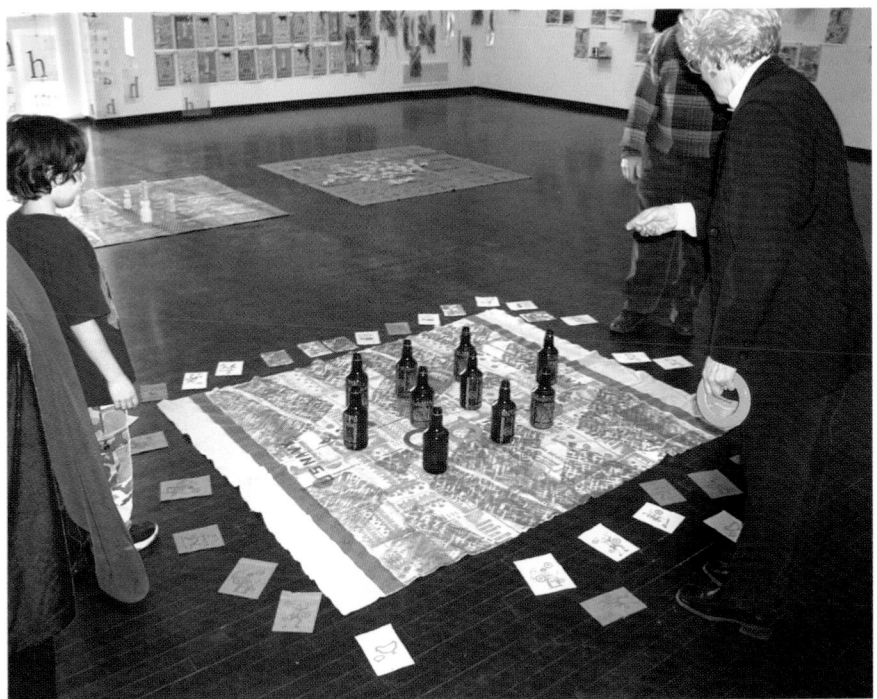

INSTALLATION

Belkis Ramirez (Dominican Republic): Woodcuts

Belkis trained as an architect at Universidad Autònoma de Santo Domingo in the Dominican Republic. Although she studied architecture she has worked as a visual artist since 1982. It's this fact that pushed her to move from working on paper to 3-D and installations. Working with the space on a one to one scale was a challenge and her main concern was whether an integration between the viewer and the artwork could be achieved.

Her practice differs from the many painters on the island. Her identity as a Caribbean islander is reflected in her work in many different ways, and she is one of the few artists, and even fewer women, with an international trajectory in her country. Being a woman particularly informs her work and is a significant influence in the issues she chooses to address. Her practice spans gender, politics and ecological issues emphasising violence within families, sexual exploitation and migration, provoking thought and hoping to create awareness through the interpretation of her critical views on socio-cultural and political issues.

Most of her work uses printmaking techniques, either printing on different materials or using the matrix as the artwork in itself as is the case in both installations featured in this book *En Oferta* and *De maR en peor*.

En Oferta deals with Dominican female migration to Europe for prostitution. She recognises the sacrifice of those women who leave their homeland and go

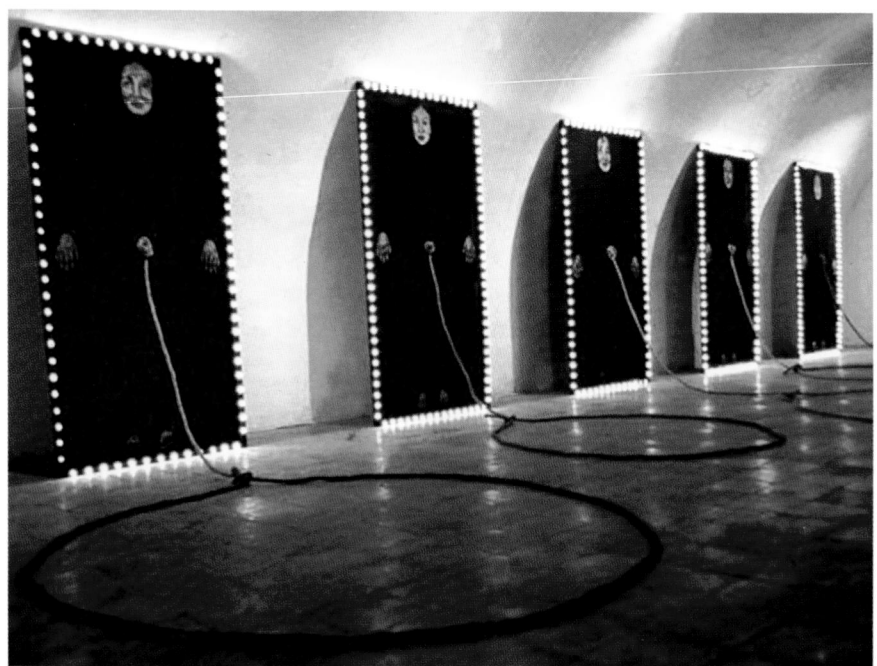

En Oferta (For Sale), Belkis Ramirez, 1996, carved and painted wood, lights and rope.

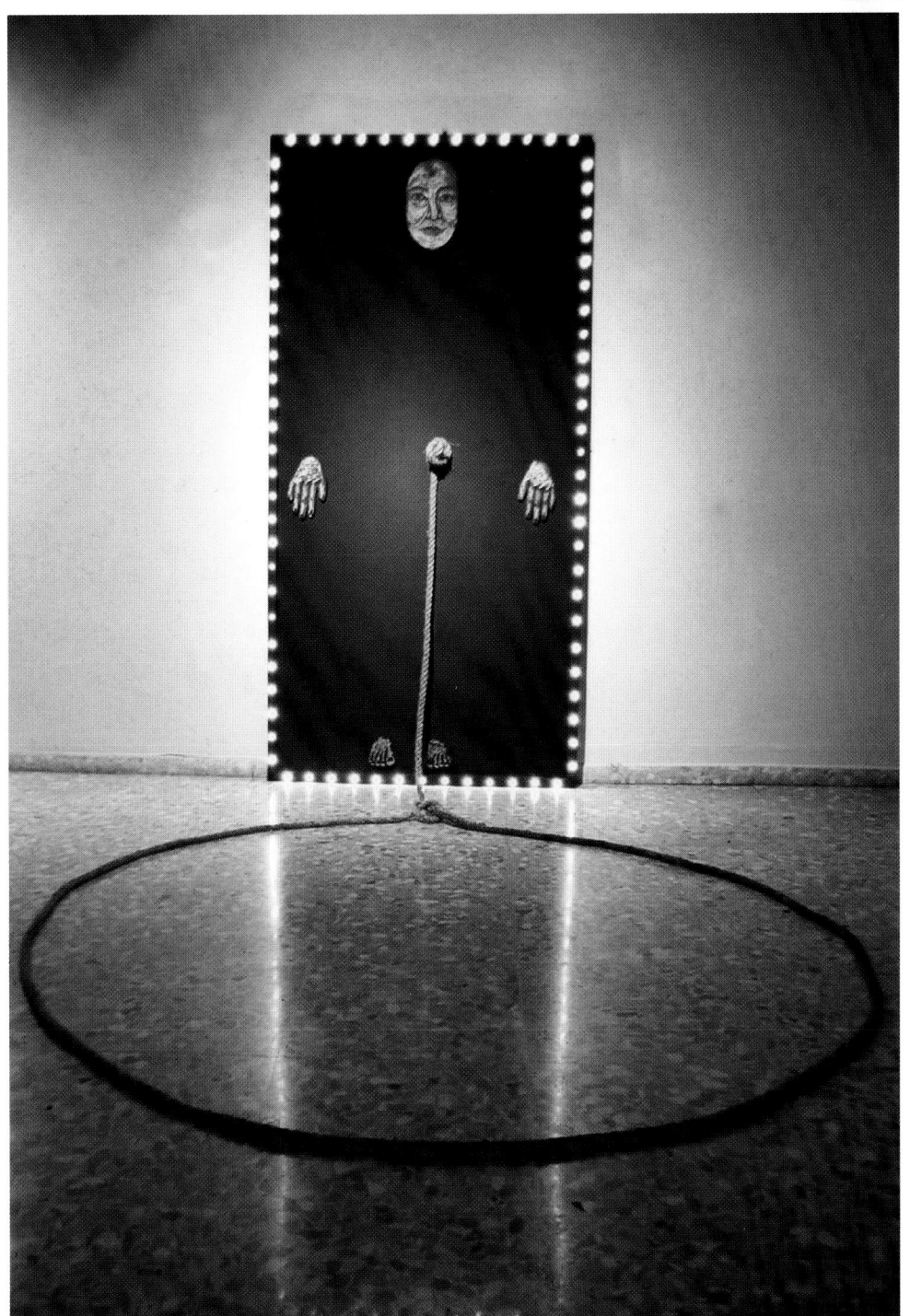

En Oferta (For Sale) (detail), Belkis Ramirez, 1996, carved and painted wood, lights and rope.

abroad in order to make money to support their families left at home.

The panels are woodcuts in which she portrays the face, hands and feet of women, one in each panel, without a body. From the belly button a rope comes out which extends towards the floor as a metaphor for ancestral abandonment. She installs Christmas lights around the panels to emphasise the 'SALE' situation, as seen in shop windows.

De maR en peor is an installation that stems from the previous one, *En Oferta (For Sale)*. It continues to reflect on sexual exploitation. It consists of 33 female figures on life size scale; they are all hanging from gigantic hooks as a fish and a metaphor for being aggressors and victims at the same time. These women are caught up in their own lives and they are also out there to catch men who will provide what they need for their family's well being.

Their eyes are deeply carved into the wood and they seem to stare at the viewer; there is so much these women have to say. There is no preconceived route dictated by the artist or curator for the viewer to take. They can make their own way through, exploring and feeling part of the work.

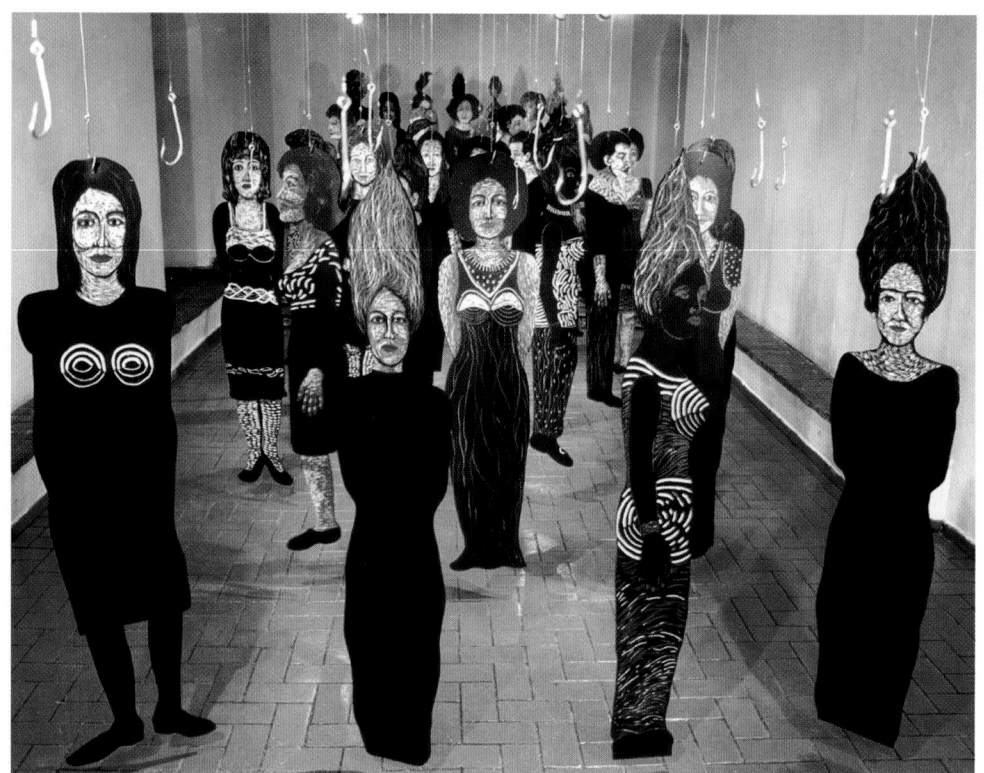

De maR en peor (From bad (sea) to worse), Belkis Ramirez, 2001, carved and painted wood steel cables, wire and hooks. Life size dimensions.

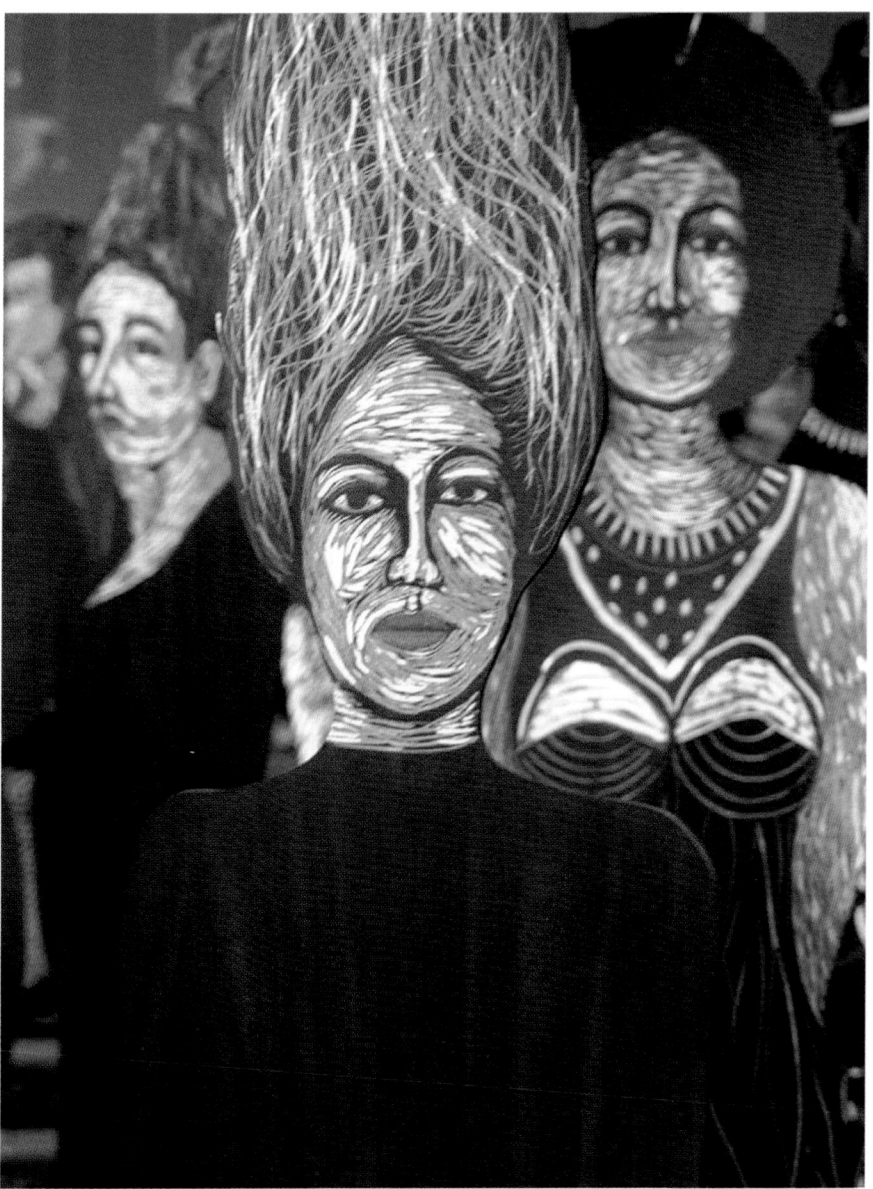

De maR en peor (From bad (sea) to worse) (detail), Belkis Ramirez, 2001, carved and painted wood, steel cables, wire and hooks.

Alexia Tala (UK – Chile): Collagraph and encaustic

Alexia's socially engaged practice deals with issues of space and society. She draws inspiration from and produces work in response to her own personal experience, as well as her research on psychological and social issues. By living

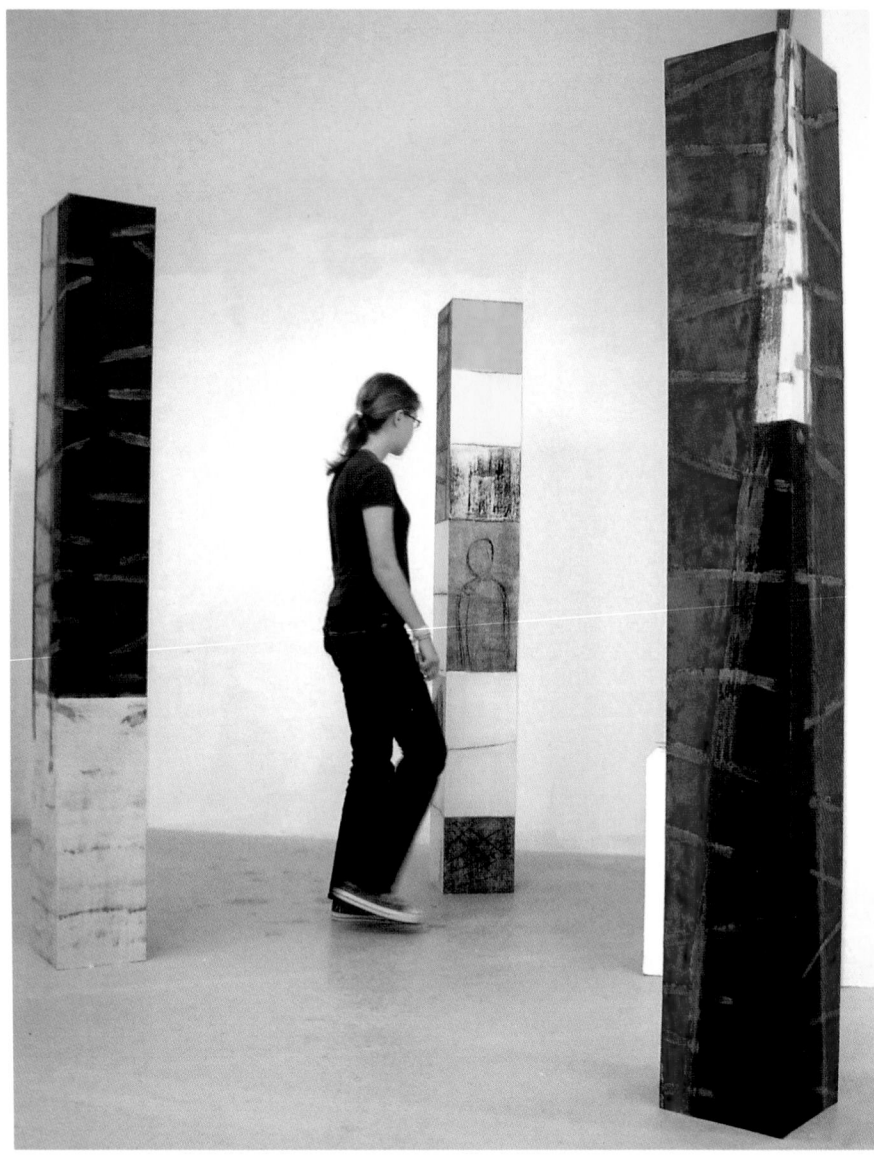

Intimate Immensities installation, Alexia Tala, 2004, four pillars 25 × 25 × 200cm / 9.8 × 9.8 × 79in., four mirrored boxes 75 × 75 × 220cm / 29.5 × 29.5 × 87in., 16 pillars 10 × 10 × 45cm / 4 × 4 × 18in. and washed sand.

in many different countries, she has developed an awareness of cultural differences and similarities.

Researching the transition of contemporary artists from 2-D to 3-D artwork inspired her to reject the 'picture' frame for prints as she believes it is a barrier.

Her work spans different disciplines including artists's books, objects, sculpture, installations and moving image; however, most of them use printmaking as a starting point.

She uses the way she displays her work to achieve a prolonged period of contemplation by the observer and in some cases changes the scale and dimension of the work, which slows down the observer as they navigate their journey through it. By doing this, her work becomes an object, a sculpture or an installation and forms an integral part of the environment.

Her work intends to produce a psychophysical response from the viewer and she tries to achieve that by stimulating other senses as well as the visual.

'My work has no frames, no glass, no barriers, the viewer is part of the piece, and it needs the viewer's response to be completed.'

The work featured here, titled *Intimate Immensities,* was influenced by the book *The Poetics of Space* written by Gaston Bachelard and the symposium 'The Poetics of Material', part of Antoni Tápies retrospective program at MACBA – Barcelona.

Alexia wanted to show her involvement with the built-up city environment of London, creating work that reflects her experience, mapping a feeling of connection between the urban city and its society.

This installation integrates all of her ideas, displaying four two-metre tall pillars that the viewer experiences by walking between and around them; the scale of the work makes the viewer aware of their own size and the tactile pillars trigger the viewer's urge to touch and feel the fabric of the work.

After passing through the pillars, the viewer is confronted with four mirrored boxes producing an infinite reflection of their own body which becomes part of the work and their experience of it.

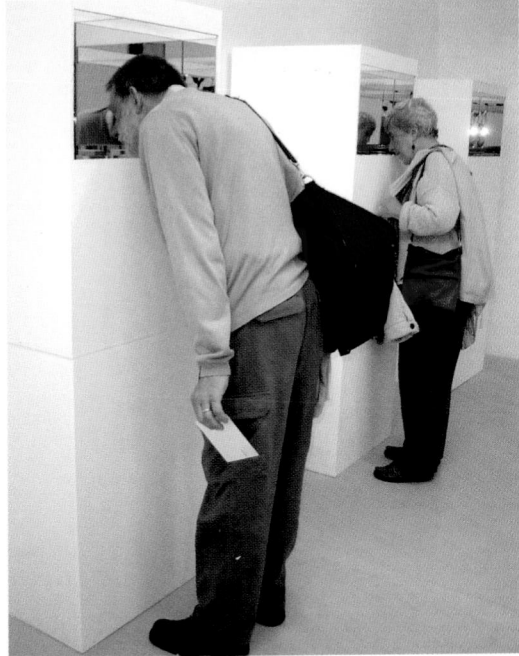

Intimate Immensities installation, Alexia Tala, 2004. Public interacting with the artwork by introducing part of their body inside the mirrored boxes

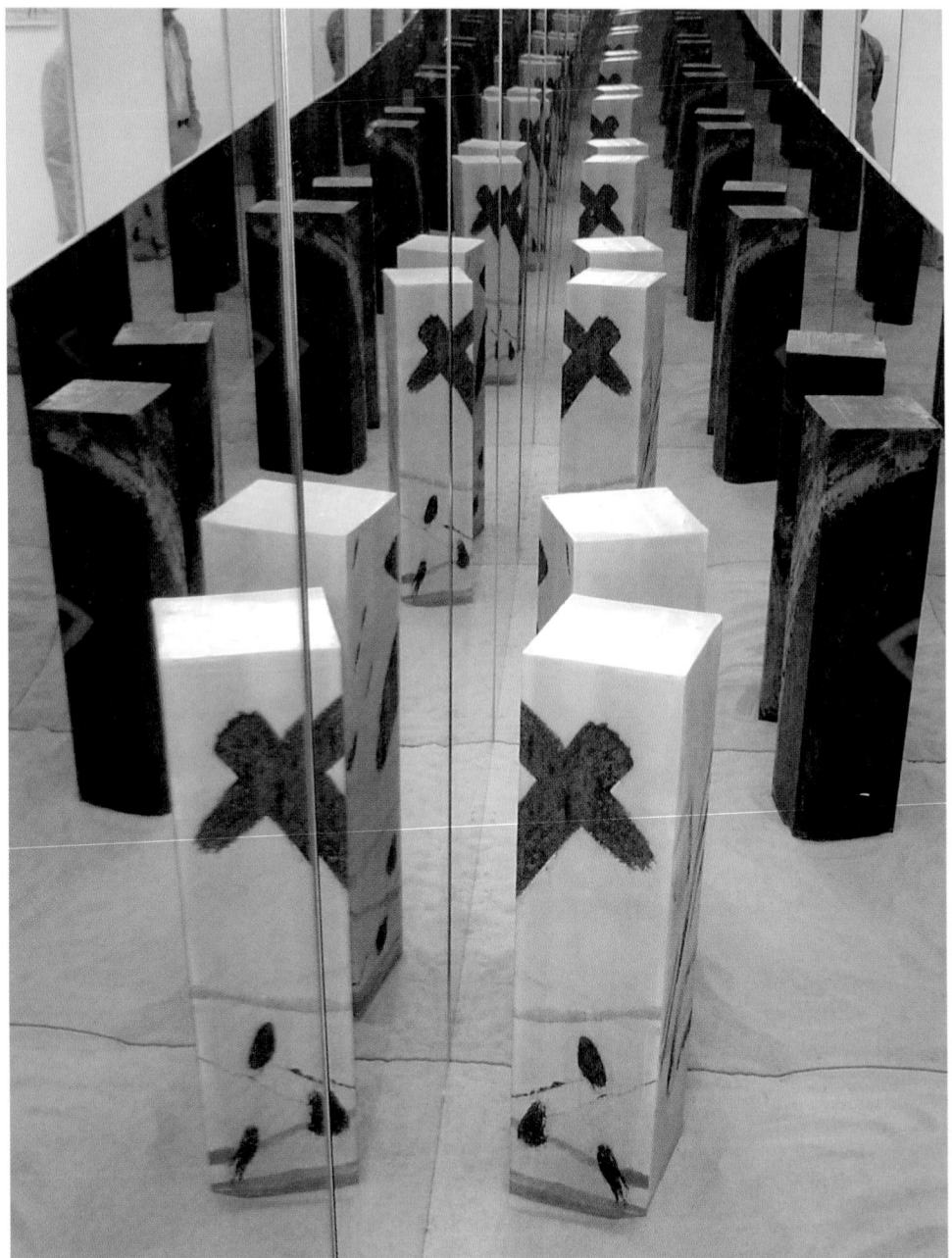

Intimate Immensities installation, Alexia Tala, 2004. Internal view of the mirrored boxes. Objects project endless reflections on the four sides of the boxes.

The technical aspects of the installation are described in the following.

The tall pillars were made out of MDF and the prints were done on extra long paper printed with monoprints and collagraphs. Four sheets of paper were printed for each pillar and, once the prints were dry, they were attached to the pillars using wood glue. The joints of the sheets of paper were made using a Japanese technique where the edge is sanded on the back, so that when both edges are joined, the paper has the same weight as the rest of the sheet.

After the prints had been attached to the pillars, collage and non art materials such as sand and scrim were added to them. Afterwards, two layers of encaustic medium where brushed on top at a high temperature. In order to do this, the pillars had to be in a horizontal position.

For the installation the pillars were secured to the floor by placing them over weighted smaller boxes. The four mirrored boxes were placed on top of plinths and filled with four centimetres of sand and the front of the boxes had a rectangular opening in order to allow the viewer to interact with the piece. Smaller pillars were placed inside. (See image on page 64.)

Woodcut onto plaster

The first memory project developed from the artist's interest in autobiographical memory within society and research into people's earliest memories.

Inspired by the first memory studies done back in 1895 by Victor and Catherine Henri, for two years Alexia collected narratives of people, known and unknown, from Chile, the UK and other countries, of the earliest memory that they are able to recall.

Then she categorised them by the feeling which that particular event stimulated at the time.

The words on the sculptures reflect the feelings and sensations of contemporary society as people start to make up their own identity and the stories of their own lives. The work is displayed on the floor and a book which records many of these first memories is on display for viewers to read.

Alexia created this work to evoke a sensory reaction within the viewer, engaging people with the physicality of the print by making unframed work (woodcuts onto plaster) and placing it on the floor in a form that the viewer will be led through. This enables them to handle and respond to the piece, and they find that their position as an observer changes to that of a participant: an explorer.

Alexia also hopes to make the viewers think of their own memories. A blank book is there for the public to record their own first memory, thus allowing them to become a permanent part of the exhibition if they wish to do so.

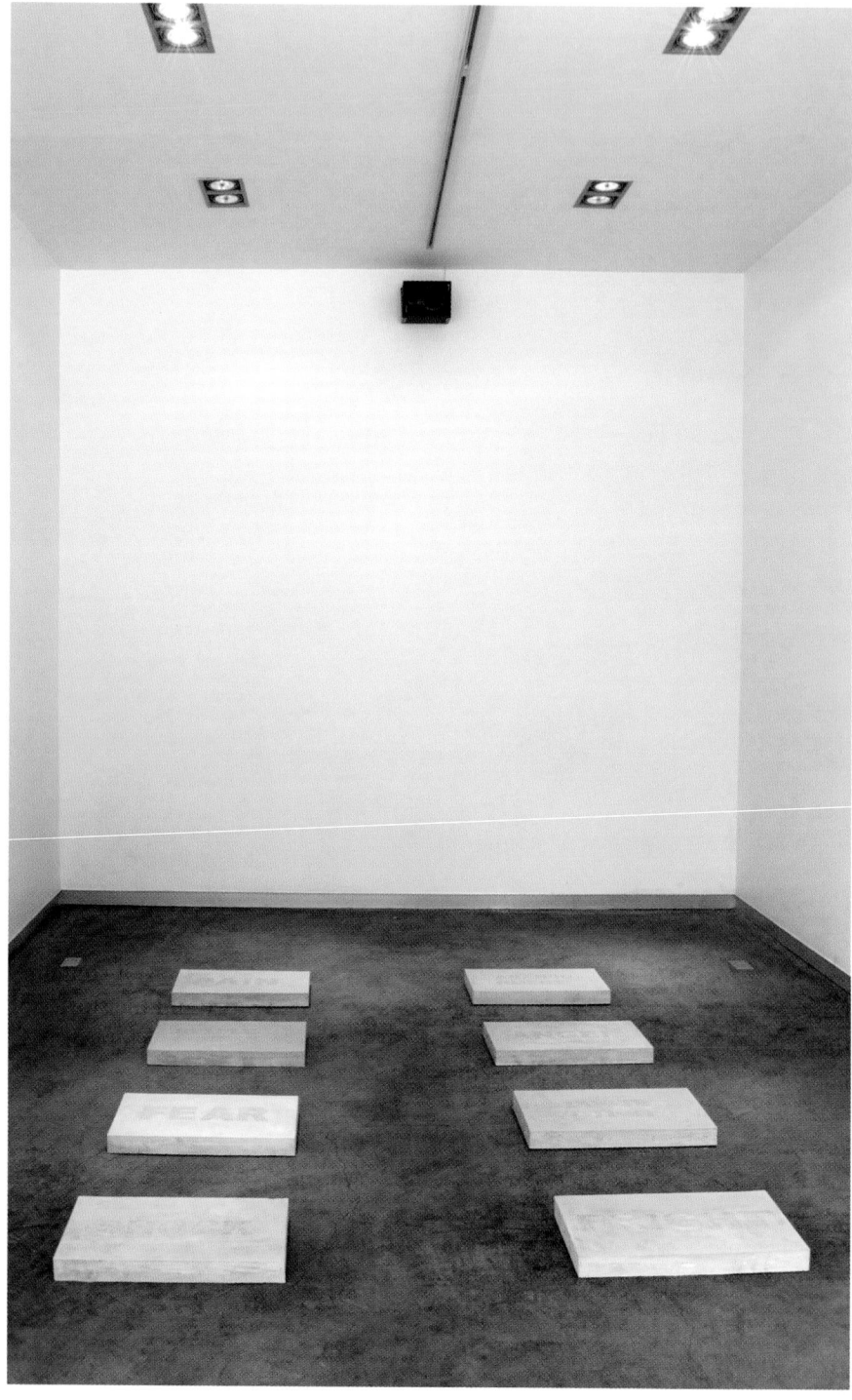

First Memory, Alexia Tala, 2008, woodcut moulded onto plaster.

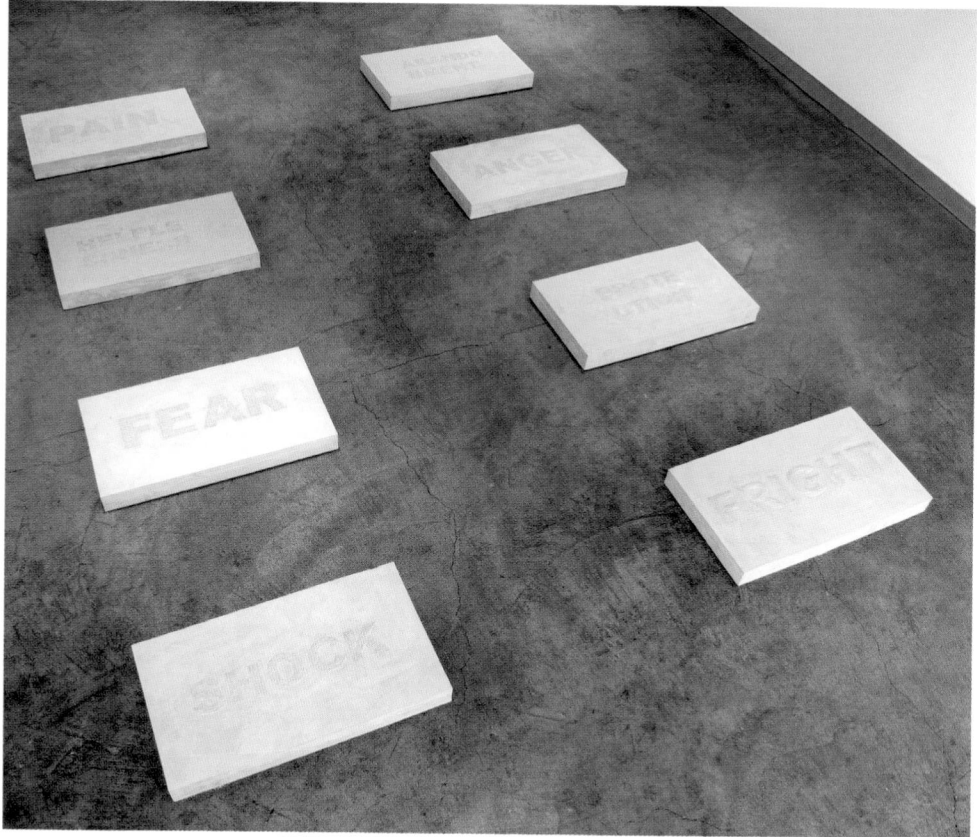

Alexia Tala, *First Memory* (detail), 2008, woodcut moulded onto plaster.

Steps:

- The wood used was MDF.
- The words were traced as mirror images onto the wood to ensure they were the right way round for the castings, and they were carved with woodcut carving knifes.
- A two inch frame was made around the woodcut plate, and secured with screws, to make the mould.
- The plate and frame were sponged with washing-up liquid to prevent the plaster sticking to the mould, and subsequently the plaster was poured onto it.
- A layer of wire mesh and a layer of fiberglass were added in between the plaster to make it more resistant.
- The moulds were left to dry for five days (in warm weather) before removing the cast.

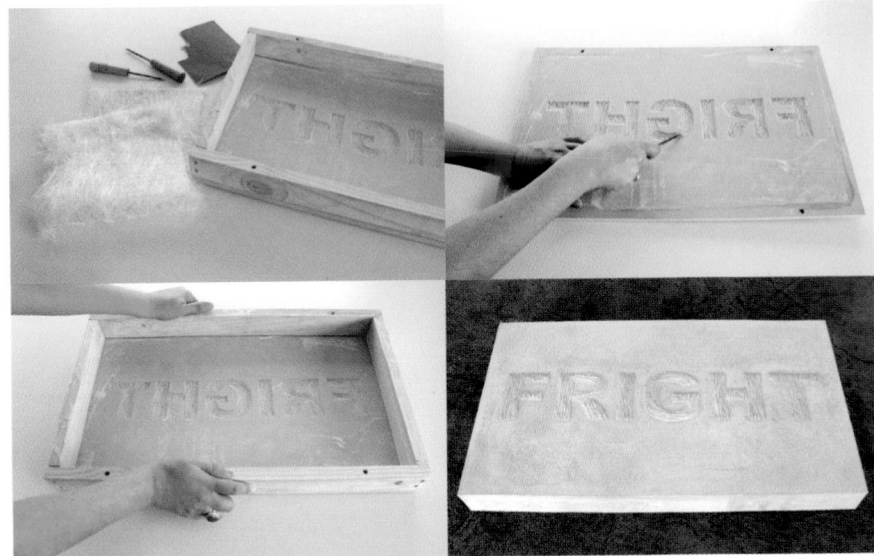

First Memory, Alexia Tala, 2008, woodcut moulded onto plaster. View of the process of carving and casting the pieces.

First Memory (close up detail), Alexia Tala, 2008, woodcut moulded onto plaster.

INSTALLATION

Helen Bridges and Alexia Tala (UK – Chile): Actions and interventions in the public realm

Little People Thoughts project was a collaboration between Helen Bridges and Alexia Tala.

Little People Thoughts reflects the thoughts of children between the ages of five and 12 years. Children were simply asked to share a thought in an unconstrained manner; they were free to convey anything they wished, writing it on a white piece of cardboard with black markers.

The results were both quirky and gave insight into the minds of the young, providing a portrait of children living in contemporary society. There is a propensity for the public to dismiss children and make judgements and infer characteristics. Consciousness is, however, shared and individuals tend to think similar thoughts irrespective of age, biological, cultural, religious or geographical roots.

The young thoughts were then scanned and printed on adhesive coloured paper and embedded within the fabric of the city and with no clues to the identity of their authors. They were available for the public to read, judge, question, make assumptions about or just simply observe.

The artists used different disciplines, from actions in the public realm by collecting thoughts, to printing the results and then making interventions in the city of London. These interventions were documented by photographing the dialogue between the public and the posted thoughts. The photographs were then printed.

This documentation of adhesive thoughts and photographs was presented together as a collage at the exhibition space for the Liverpool Biennial – Independents 2006.

Little People Thoughts, 2006, Helen Bridges and Alexia Tala. Public reading inkjet printed stickers at Clapham Junction Station – London.

Zoe Schieppati-Emery (UK): Silver gelatin and glass

Zoe's art practice concentrates on the body and the human condition, either in a figurative sense or using the body as a starting point for a more conceptual piece.

She is particularly interested in the idea of trying to capture and treasure a moment, the essence of a person and/or emotion, attempting to make substance of or represent something which, of its very nature, is transient; exploring that which is unique to us and yet common to all of us.

Extracting ideas from science, history and mythology, she works with a wide variety of materials in an attempt to portray the beauty and sometimes the pain of our life's experience.

Themes of life and death have fascinated the artist, such as the fragility of the body as our life-long container and our only real possession.

The installation featured here consisted of vitrines (specimen jars) which the artist had filled with photographic images of the human body on a 6 feet sq. light box. As photography notionally captures a moment and portraiture

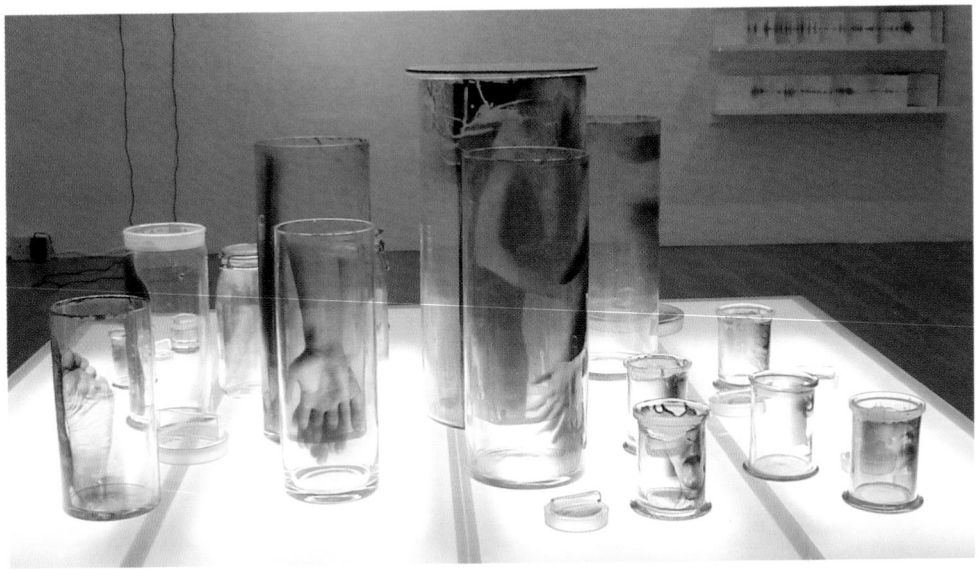

Capture, Zoe Schieppati-Emery, 2004, light box, glass jars. Overall dimension 71 x 71 in. / 181 x 181 cm. glass jars up to 59 in. / 150 cm.

'If photography belonged to a world with some residual sensitivity to myth, we should exult over the richness of the symbol: the loved body is immortalised by the mediation of a precious metal, silver (monumental and luxury) to which we might add the notion that this metal, like all metals of alchemy is alive.'

(Roland Barthes, 1993, p. 81)

attempts to immortalise the mortal, the vitrines reiterated the sense of trying to hold, treasure and preserve something that is as fragile, unique and individual as the human body. By using a light sensitive emulsion, "silver gelatine" (aka liquid light), directly on the glass, the 2-D images gained an elusive almost magical quality as they pushed into the 3-D.

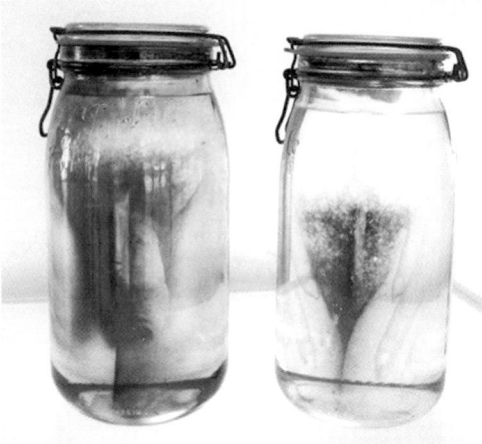

The glass vessels filled with corporeal images reiterate the sense of treasure and conserve something that is as fragile, unique and individual as the human body. While capturing a historical moment of light reflecting off a body, both a moment and a body fragment are bottled and preserved.

Origin of Species (or would you Adam and Eve it!), Zoe Schieppati-Emery, 2004, liquid light on glass, two Le Parfait super storage jars, 31.5in / 80cm high each. They are images of the human penis and vagina, the very mechanisms of our physical beginnings.

Zoe applies silver gelatin and exposes the jars in the darkroom. Once the image is fixed, she fills them with oil; reference is made not only to scientific preservative liquids but also to the oils used in embalming, which symbolically consecrates life. The oil gives the images unexpected depth almost attaining another dimension. Elusive and magical, the images appear, disappear and distort as you move around them.

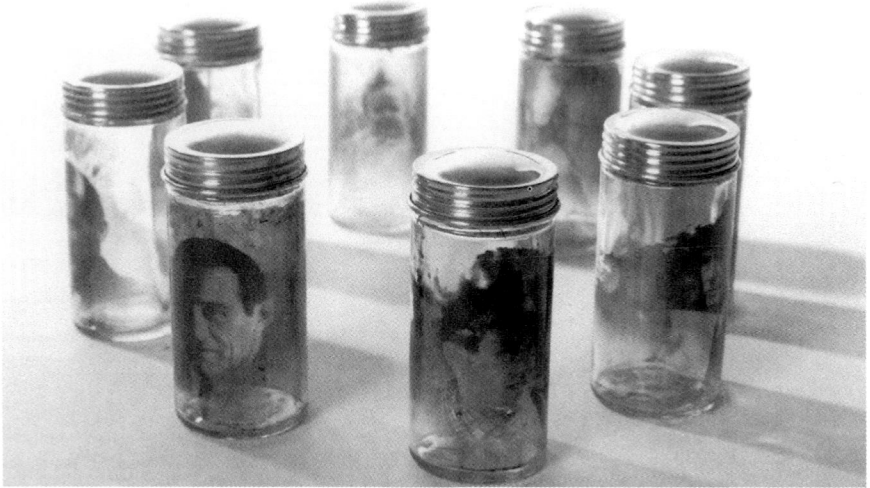

Life Cycle, Zoe Schieppati-Emery, 2004, liquid light on glass, eight glass bottles with metal tops each 4in. / 10cm high. Space for display is variable. Playing on Shakespeare's reference to the seven ages of man, this piece is made up of images of man's life cycle, from child to old man.

INSTALLATION

Juan Castillo (Sweden – Chile): Silkscreen on Perspex

Juan is an established member and one of the creators of the CADA group, well known in Latin America for their actions and performances in public spaces. He is an artist who usually participates in international biennials and museum exhibitions. His practice of art is based on studying society.

The work in this book is a project which was the result of a four months residency at Galeria Metropolitana, Santiago, Chile in 2001, titled *Geometria y Misterio de Barrio (Geometry and Mysteries of a Neighbourhood)*.

It consists of several interviews with local people from a marginal neighborhood, 'La Victoria'. They talk about their dreams, hopes and aspirations in life as well as their night dreams. It was up to each individual to decide what kind of dream they wished to record on video. All interviews took place in the person's living rooms.

The artist also photographed the front of each person's house and their most beloved object.

The project divides into three parts.

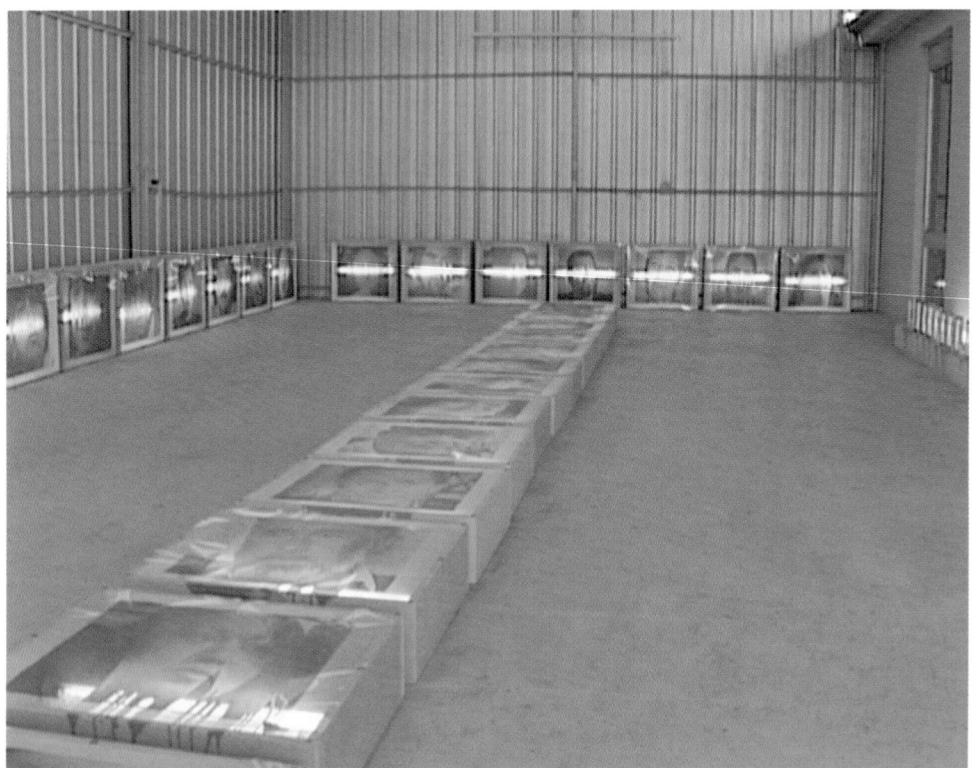

Geometria y Misterio de Barrio (Geometry and Mysteries of a Neighbourhood), Juan Castillo, 2001, site specific installation, silkscreen, lightboxes and paraffin wax. Dimension variable.

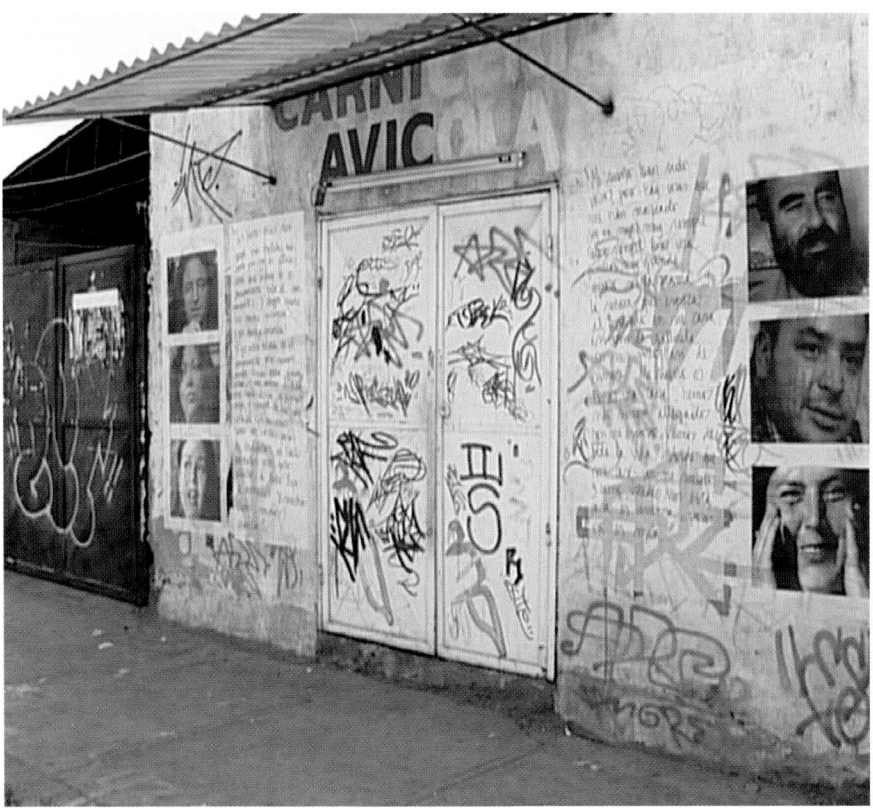

Geometria y Misterio de Barrio (Geometry and Mysteries of a Neighbourhood), Juan Castillo, 2001, urban intervention, silkscreen on paper. Dimension variable

The first one is a site specific installation. As a metaphor for broken dreams, the videos were projected on the ruins of what once was going to be the best hospital in Latin America, located in that neighborhood.

For the second part, the artist made an installation in the gallery space, consisting of the documentation of their favorite objects and 40 wooden boxes with the portraits of the dream tellers lit from behind.

Finally, an urban intervention took place, where fragments of the dreams together with portraits were printed and glued on the facades of houses all around the neighborhood.

Steps:
- Wooden boxes were made out of pine, lit with 25 watt fluorescent tubes and covered with digital prints on Perspex and splashed with hot paraffin wax.
- The portraits displayed on the streets were silkscreens. The prints were made using black ink on white paper.

INSTALLATION

Marilene Oliver (UK): Silkscreen on Perspex; silkscreen on glass; etched copper

Marilene's work is characterised as a mix between printmaking and sculpture. Her practice questions what a portrait is, the common definition of a portrait is a similarity or a representation but that was not enough for Marilene and encouraged her to push the boundaries toward finding a way to portray the internal. She felt that the external portrait is valid but there was another type to explore, 'portraying the invisible'. Her fascination for capturing the invisible has led her to explore in different ways in order to portray the body.

During her MA studies at the Royal College of Arts, she came across 'the Visible Human Project' on the internet. Joseph Paul Jernigan, a murderer who donated his body to be sliced and photographed after his death sentence was executed, all in favour of medical research. The artist saw the similarity to MRI scans (Magnetic Resonance Imaging) and started experimenting with it. Since that time she has been engaged with the use of DICOM (Digital Imaging and

Family Portrait, Marilene Oliver, 2003, silkscreen on Perspex. MRI scans screenprinted onto sheets of clear acrylic and then stacked at 2cm intervals to recreate the body. Approximately 90 prints per body.

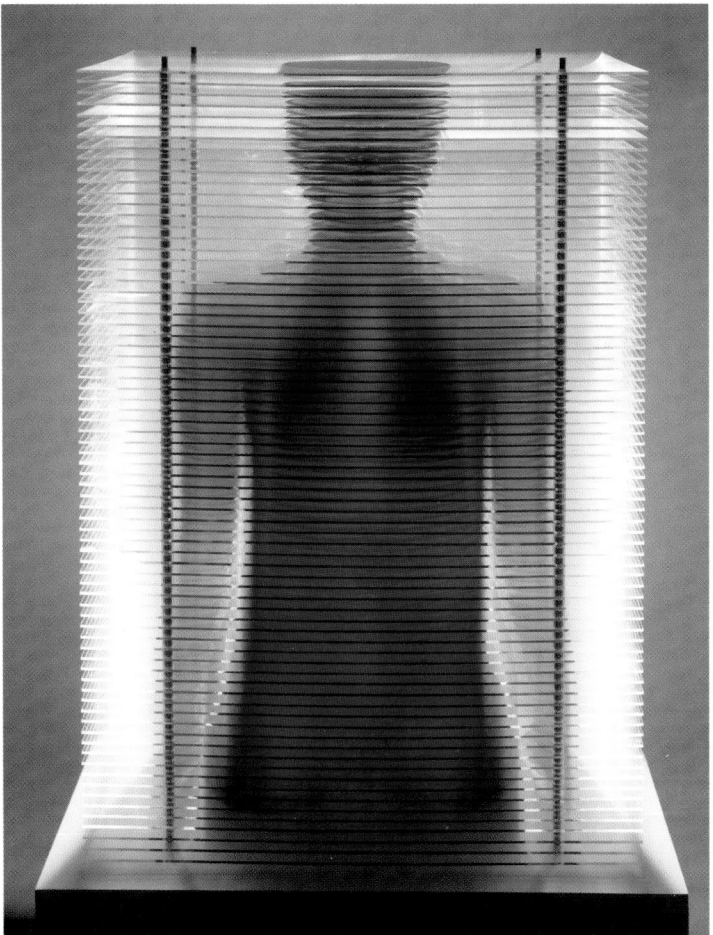

Radiant, Marilene Oliver, 2005, Inkjet print on acrylic, 50 × 70 × 100cm

Communications in Medicine) and has produced work with many different softwares. Some of the work featured in this book is a product of that.

She created *Family Portrait* in 2003. 'The MRI scans faithfully and objectively tell us not the superficial, but what is inside the body, hidden beneath the surface. I wanted to explore alternative and poetic ways of using medical imaging and to repair the fragmentation and dislocation it promotes'. The ghostly images of *Family Portrait* appear and disappear as the viewer moves around them. They also change when looked at from different heights. The artist's family members were MRI scanned and the results of each body were printed onto sheets of clear acrylic and then stacked with a separation of two centimetres to recreate each body. Approximately 90 prints were used per body.

Another piece exploring the same idea is *Radiant*. The artist used PET (Positron Electron Tomography) in order to produce this artwork. This is a

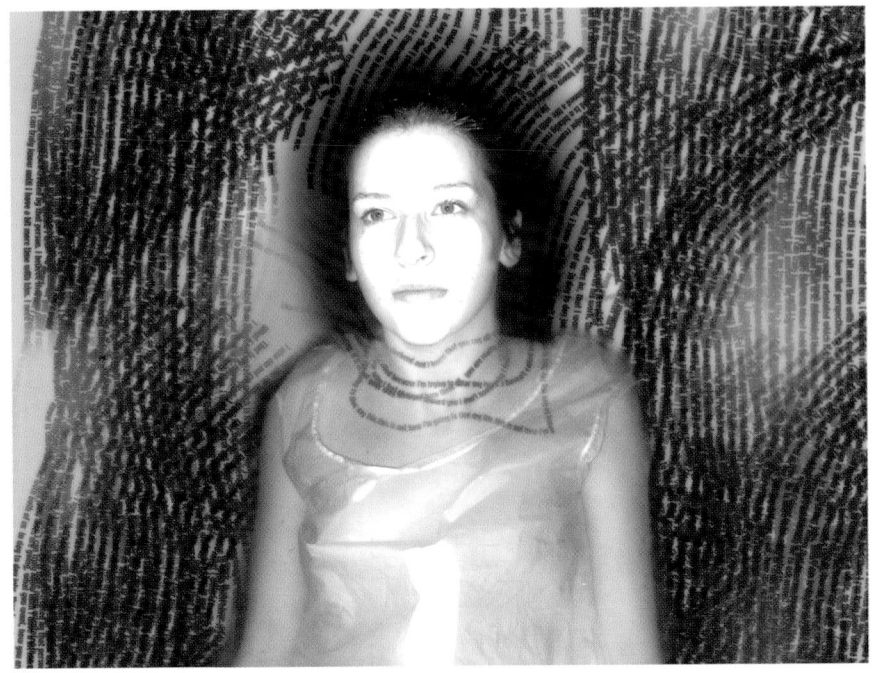

Ophelia, Marilene Oliver, 2003, silver ink screenprinted onto glass, mounted in a lightbox. 59 × 39 × 10in. / 150 × 100 × 25cm.

nuclear imaging system. It works by administrating an isotope to the patient before the scanning. The effect of the isotope is to highlight the areas that are functioning inside the body (yellow, green, red areas). As opposed to MRI system, PET shows the functioning of the body and does not portray the anatomy, as MRI does. The artist defines this piece as the documentation of a mysterious spectacle that happens invisibly inside the body.

Ophelia explores the paradox of contemporary life which is overloaded by communication. This woman is drowning in words, swamped by her own words from internet communications. This piece is composed of six layers of screenprinted glass stacked on top of each other into an MDF box lit from beneath. The text printed on the glass is taken from e-mail messages, and the different tonal value on each layer provides a subtle 3-D effect.

In order to create *Text Me* the artist saved all text messages received for a period of two and a half years. This method of communication is seen by her as an intrusion into people's privacy. People are constantly receiving text messages no matter where or what time. She uses the arrows with text as a metaphor for piercing language and the invasiveness of contemporary communication systems. Copper spikes were etched on both sides with text messages. The text was screenprinted with an acid resist and then etched with ferric chloride acid. The spikes were then screwed onto a life size cast of her own body.

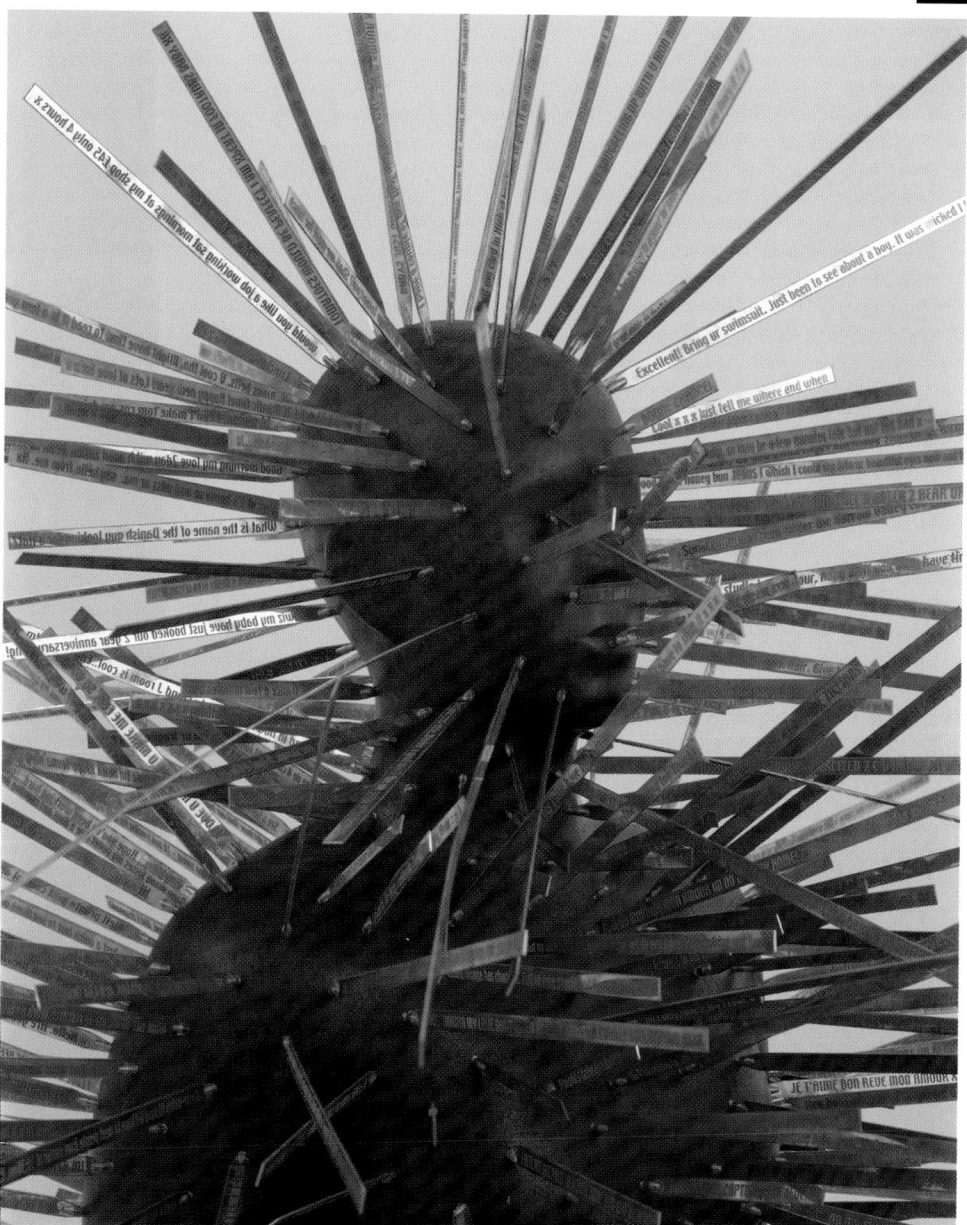

Text me, Marilene Oliver, 2003, cast bronze and etched copper spikes, 79 × 59 × 59in. / 200 × 150 × 150cm.

'*Text Me* is an eloquent joke, a humorous response to the thickets of signals we negotiate every day. And the obverse of the piercing is defence. This body has its own force-field. The texts are protection as well as intrusion.'

(Jeanette Winterson, 2003, exhibition essay 'Intimate Distances')

Claire Nash (UK): Collagraph on latex

The foundation of Claire's work primarily lies within a sense of colour integration and textures, created directly from her emotions, fed through her hands and onto her work.

She has created her own language of shapes and colours which are synonymous to her cerebral activity.

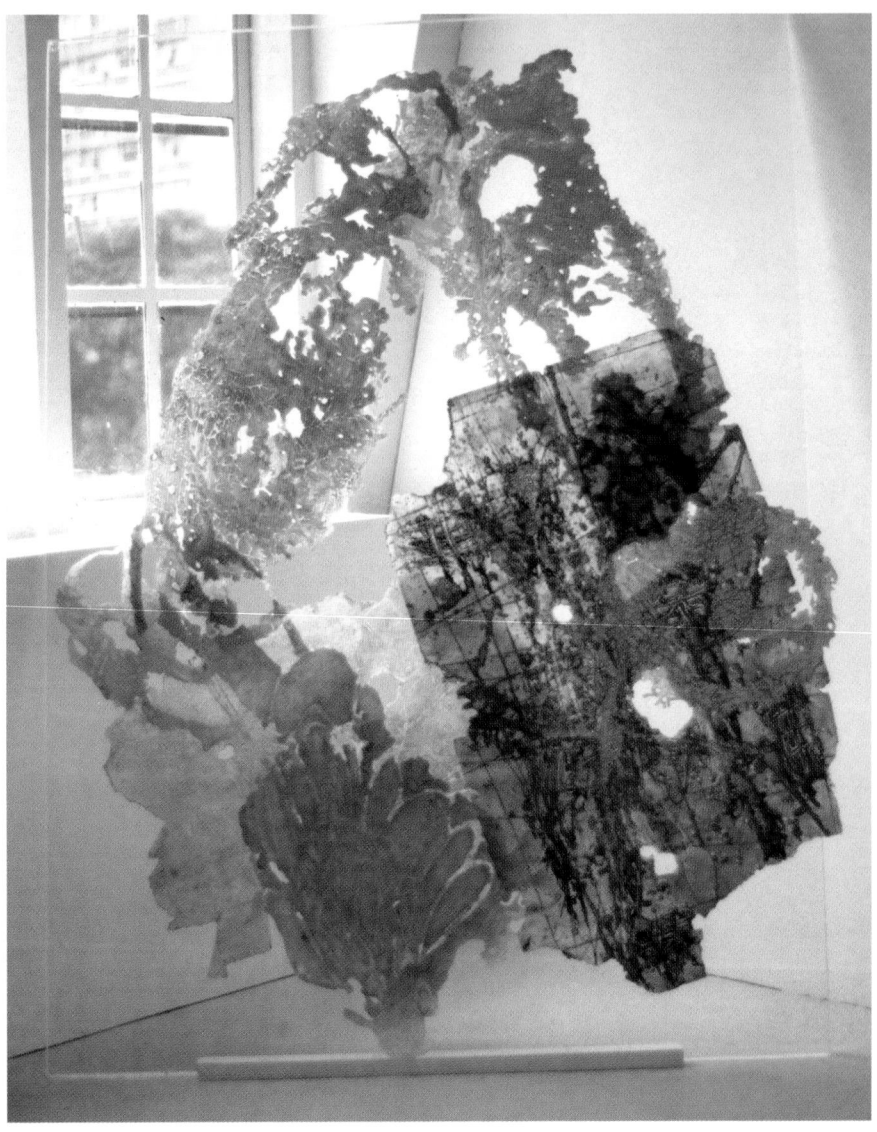

Cerebral Intuition, Claire Nash, 2004, collagraph relief emboss and mixed media, 86.6 x 59in. / 220 x 150cm.

Cerebral Intuition (detail), Claire Nash, 2004, collagraph relief emboss transferred onto latex surface.

Her work has raw, spontaneous and energetic aspects, not only in the way it looks once finished, but also during the experience of seeing her at work in the studio when making the plates. Most of her work derives from the collagraph process; this is due to the sheer intensity of varying depth, textures, and tactile organic surfaces that is achievable from this technique. At present she is experimenting with various methods of casting her work using different materials, in order to sum up her feelings, like a 'freeze frame' of how she felt at that moment whilst creating each piece.

The pieces featured in this book are part of the latex series, a material which the artist chose to work with as a close representation of her skin, allowing her to encapsulate her emotions within an organic and tactile material, representative of our very make-up. Claire uses a large array of materials when making her plates, for example: gloss paint, matt emulsion, yachting varnish, glue, carborundum, texture gels, glass beads, sand, filler and many more. She also uses cordless power tools to create intaglio relief although rather crude; this adds a drawn line and structure to the plate.

Steps:

- Start with the collagraph plate by using a thin sheet of wood, generally MDF or hardboard. Hardboard already has a sealed surface and will be a more resilient plate; however, MDF is easier to cut into.
- Paint a cross on the back of the plate and allow it to dry; this will prevent the

INSTALLATIONS AND EXPERIMENTAL PRINTMAKING

INSTALLATION

Cerebral Intuition (detail), Claire Nash, 2004, collagraph relief emboss and mixed media. Dimensions of the full installation 86.6 × 59in. / 220 × 150cm.

plate from warping when moist materials are added during the creation of the plate.

- When the plate is dry, it is ready to use. Unlike many printmakers, Claire does not seal the plate with shellac or varnish as she finds it suppresses some of the tones she is hoping to achieve. Inevitably this will lead to the plate breaking down sooner; however, this would only affect a printmaker who creates editions of the same print.
- To create an embossed relief of the plate, the latex must be brushed on layer by layer, allowing each one to dry before applying the next; how many layers are applied depends upon the desired depth.
- Once dry, a coating of talcum powder is rubbed all over the latex; this will prevent it from sticking to itself when it is peeled off.
- When the latex has been removed, the result is an embossed surface that mirrors the collagraph plate.

This latex emboss can be displayed as it is, or the plate can be inked, placing the emboss back onto it and running it through the press, thereby achieving a latex emboss relief print.

Another method is to ink the plate, and immediately start brushing on the layers of latex. The result is that when the latex is peeled off of the collagraph plate, there will already be a print revealed. Either this piece can be finished, or you can ink up the plate with a further colour and run through the press to create multiple layers on the latex.

Thomas Kilpper (Germany): Woodcut on flooring

Thomas lives and works in Berlin, although travelling and working on site specific projects is an integral part of his practice.

Inspired by Gordon Matta Clark's attacks on empty buildings, his interest is mainly with space and its social function and history. He tries to get spaces that have not previously been an institutional art-space before. 'I love occupying abandoned spaces and buildings and bring some life back to them and extend the use of such space for the arts.'

In 1999 he worked on a big woodcut project titled *Don't Look Back* and, although he had decided never to work on woodcuts again he never expected what would come of his trip to London looking for a space to undertake another project.

This trip resulted in the *Orbit House* project, a building in Southwark, London, which held the

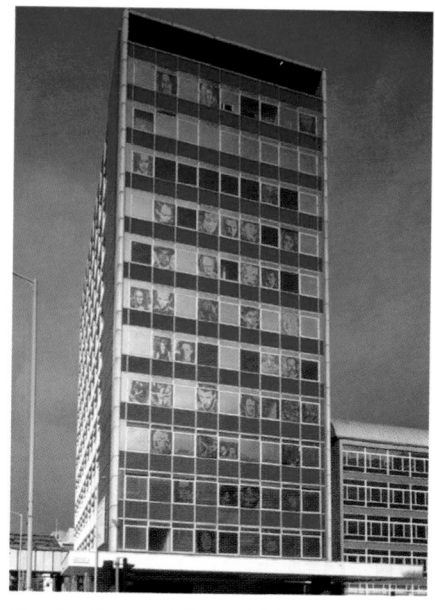

The Ring, Thomas Kilpper, 1999–2000, woodcut on flooring (parquet). View of interventions on the building by covering windows with printed images of the project that was taking place inside. Southwark, London.

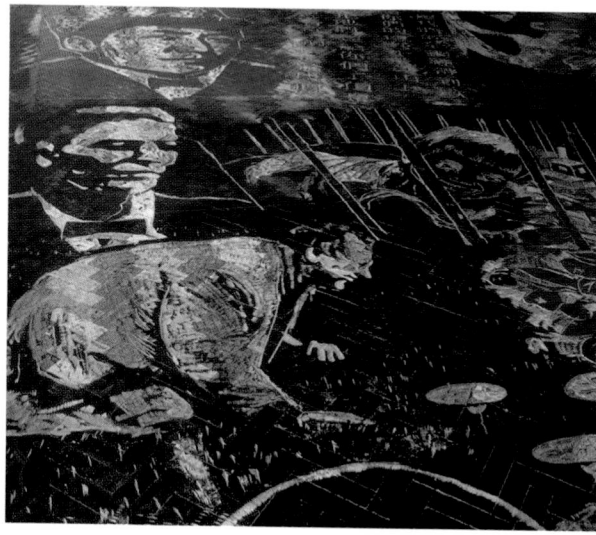

The Ring, (detail), Thomas Kilpper, 1999–2000, 400m sq. Woodcut on flooring (parquet). At Orbit House, London.

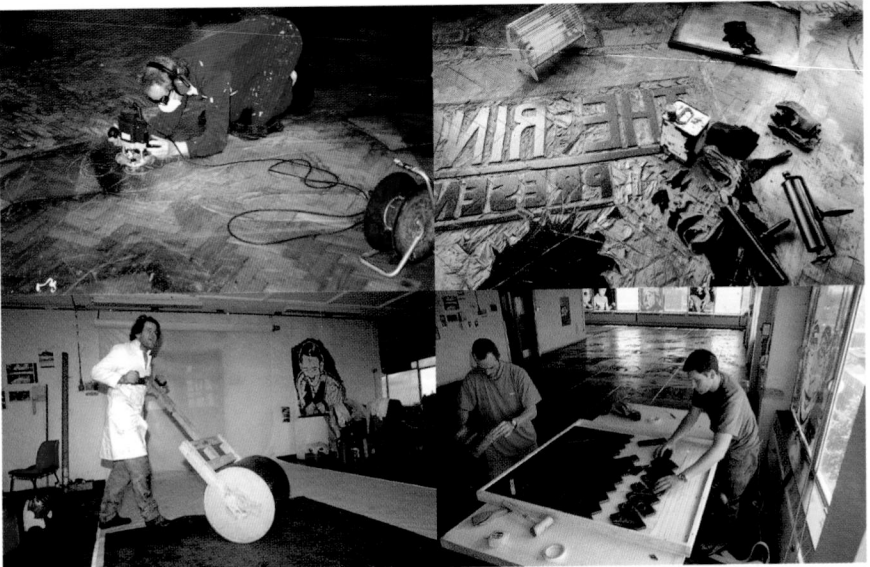

The Ring, Thomas Kilpper, 1999–2000, installation view of printed fabric. The images are taken from woodcuts the artist carved onto the buildings floor on the 10th floor. Orbit House building in London.

Thomas Kilpper, 1999–2000. View of the process of the Orbit House project.

former East-India Collection of the British Library. Thomas investigated the history of the building and learnt that Orbit House hosted not only lovely herring-bone parquet floors but also, and most important, for about three decades the oldest woodcut in the world as part of its collection.

'I took it as a hint or even an order — and had to cut the wooden parquet once more.'

The artist occupied the building for a period of one year. He carved directly on the parquet floors; seven months were spent carving and around five months printing.

Although technically he works on the floors, when it comes to display he uses all the space available, hanging from ceiling and windows, converting the artwork into a site specific installation project.

Libby Hague (Canada): Woodcut on paper

Libby's main theme is the precariousness of civilised life; her preoccupations are with disaster and the thrill and pity of vicarious destruction, but more importantly with the possibility of rescue in a time of disaster.

In the woodcut series *Everything Needs Everything* (of which *Rehearsal for Disaster* is a part) this is set under the Gardiner Expressway in Toronto at an apocalyptic future moment that feels closer all the time. It could be any

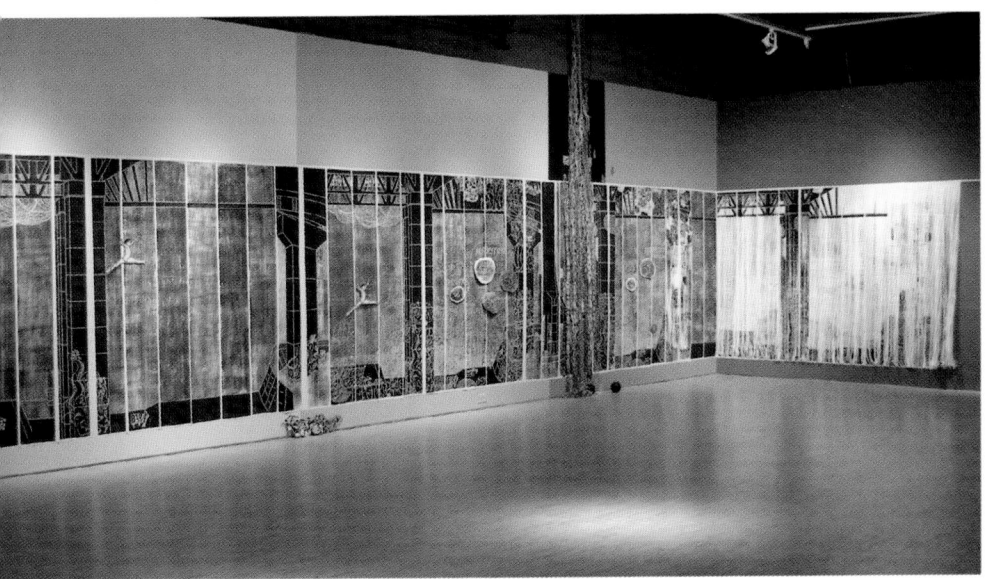

Everything Needs Everything, Libby Hague, 2005, woodcut on Okawara paper, 6 × 54ft / 1.8 × 16.5m.

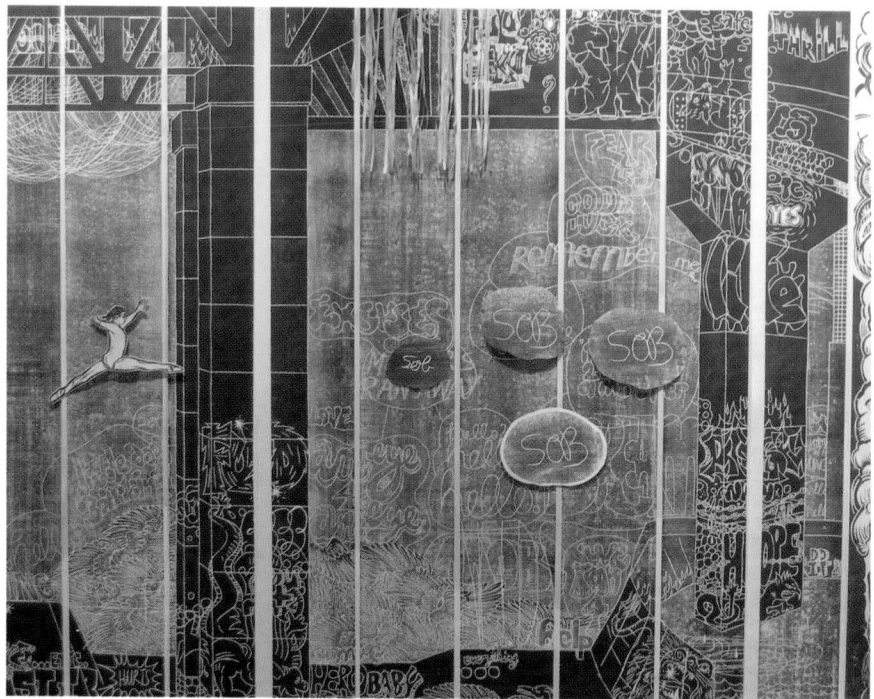

Everything Needs Everything (detail), Libby Hague, 2005, woodcut on Okawara paper, 6 × 54ft / 1.8 × 16.5m. Additional prints are added on top of the panels and some figures hang from the ceiling.

threatened modern city. Here, poised in the tense uncertainty of mid-fall we come across a crisis between two protagonists, a baby and a young female athlete. The baby needs help and the girl needs something to believe in. Theirs is a relationship of mutual dependency, of not giving up and not giving up on each other. 'We don't know the outcome but we can admire their courage and willingness to risk and engage.'

Woodcut panels are pinned to the walls to build an apocalyptic scenario in which a crisis between the two protagonists can play out. The flexibility of the pinned panels means the installation can be big or small; however, Libby usually prefers large scale installations that hope to overwhelm the viewer.

By approaching printmaking as a combination of manufacturing and hand process, she tries to keep the efficiencies and adaptability of both. She works within a modular system which, when combined with the printed multiple and the repeated pattern, is highly adaptable. The work is pinned to the wall and everything can be reconsidered and moved around easily. Making holes in the prints was one of the big taboos she had to overcome.

The basic modular size is dictated by the size of the paper sheets (72 inch long sheets of Okawara) and the basswood boards. The paper is very strong

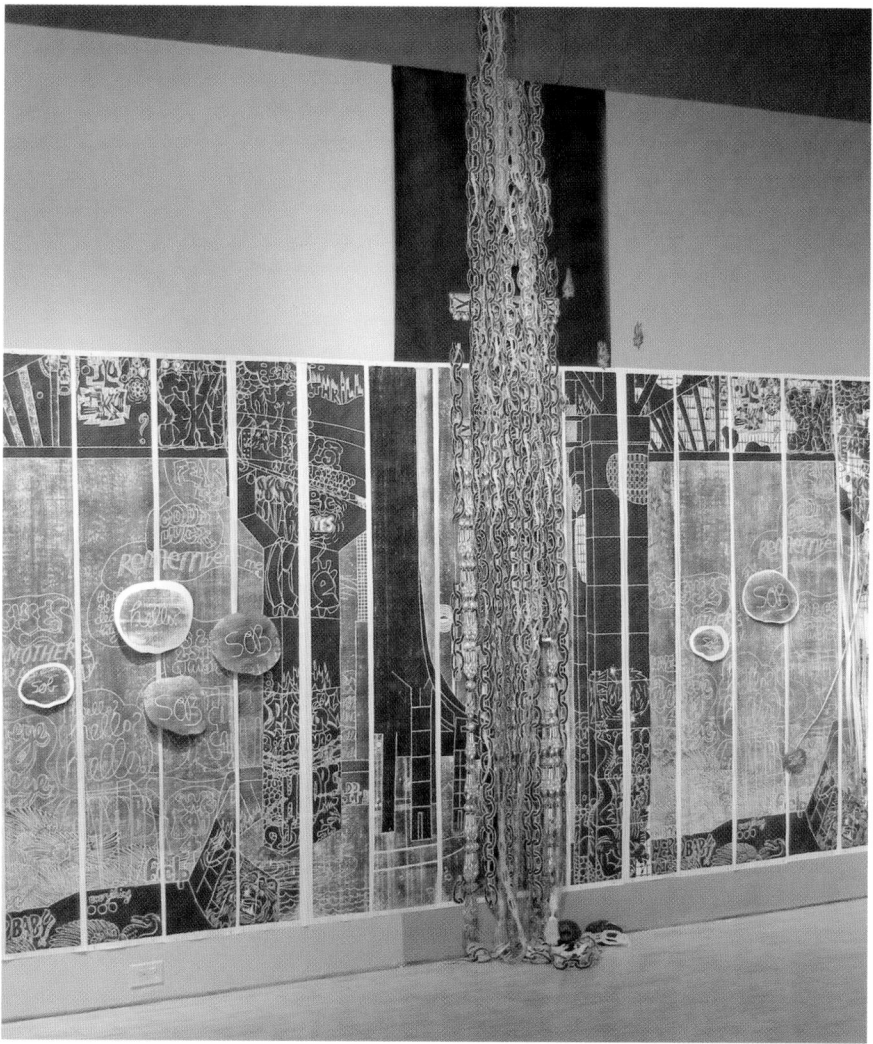

Everything Needs Everything (detail), Libby Hague, 2005, woodcut on Okawara paper, 6 × 54ft / 1.8 × 16.5m. Paper chains made out of printed paper hang from the ceiling and add to the 3-D composition of the installation.

and pliable even when cut in thin strips, but sometimes she adapts a Chinese wet mounting technique to laminate the paper so that she can give the figures and particular elements a stiffer texture. Since she often points a fan at the work to create movement, it is useful to have things weighted differently to be able to control the movement. Most of her work is printed in black or dark grey, but since the printing is done by hand with a wooden spoon, she can modulate the ink by using a variety of hand pressures; the colour is added with acrylic washes and the blocks are cut with very sharp Japanese chisels.

Nicola López (USA): Woodcuts and silkscreen on Mylar®

The world that we live in today is filled with signs of constant movement and instant communication, fueled by society's desire for ever increasing wealth, bigger and better possessions and the latest technology. Nicola López builds pieces that incorporate these signs, exaggerating and reconfiguring them to convey the inevitable feeling of awe and amazement that is experienced in the modern world.

> 'I draw on the visual language of cartography in order to evoke the idea of mapping, although my maps do not refer to actual places. Neither are they depictions of utopias or dystopias; they are maps that represent how our actual world is structured, not on a literally geographical, but on an experiential level.'

Her work represents the construction of the modern city. She builds up each piece by using both images and raw materials to reflect the history and architecture of the urban landscape. She uses printmaking to reflect modern developments in technology, such as the industrial revolution.

Some of her work is planned out in advance. Other pieces do not follow the original plan, and grow organically. This constant conflict between the planned and unplanned is reflected in her landscape maps and images.

A Promising Tomorrow, Nicola López, 2004–2005, woodcut on paper and Mylar®. Room dimensions: 12 × 14 × 12ft / 3.7 × 4.3 × 3.7m.

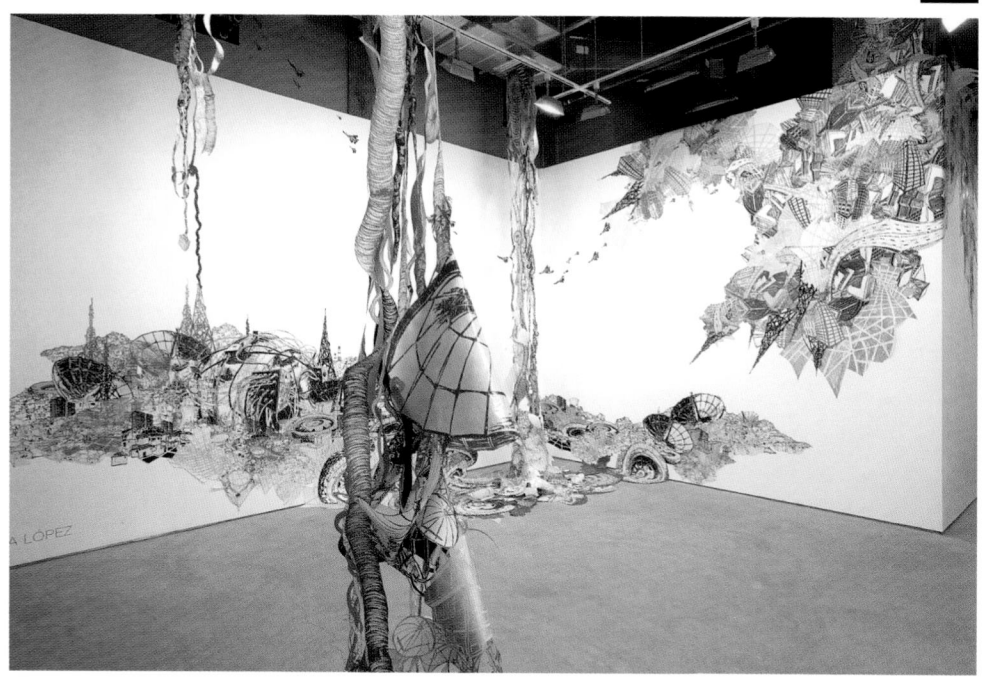

Vertigo, Nicola López, 2005, mixed media. Dimensions variable.

Her pieces do not set out the path through the work for the observer but leave the viewer to find their own way.

Her process consists first of developing the individual images from which an installation will eventually be constructed. At the initial stage she confesses to only having a general idea of what the installation might look like.

> 'I think of these elements both in terms of content – what each image portrays and what role it will play in the general narrative of the piece – and in terms of its formal quality – whether it is an element that connects, that clumps, that stands on its own, that can become three-dimensional, that can appear only once or many times, etc.'

Most of her images originate from drawings that are then made into silkscreens or photo-lithography plates. Sometimes she uses woodblocks. The largest images might be as big as four feet by five feet, but most of them are much smaller.

Once she has all the plates with images ready, she prints them onto paper or frosted Mylar®, a very strong and flexible material, which continues to hold its shape over time without sagging in the way that paper often does.

Once they are dry, she proceeds to cut the images out, often removing the negative spaces inside an image with an exacto knife.

At this point, all of the raw material is ready and the installation can be put

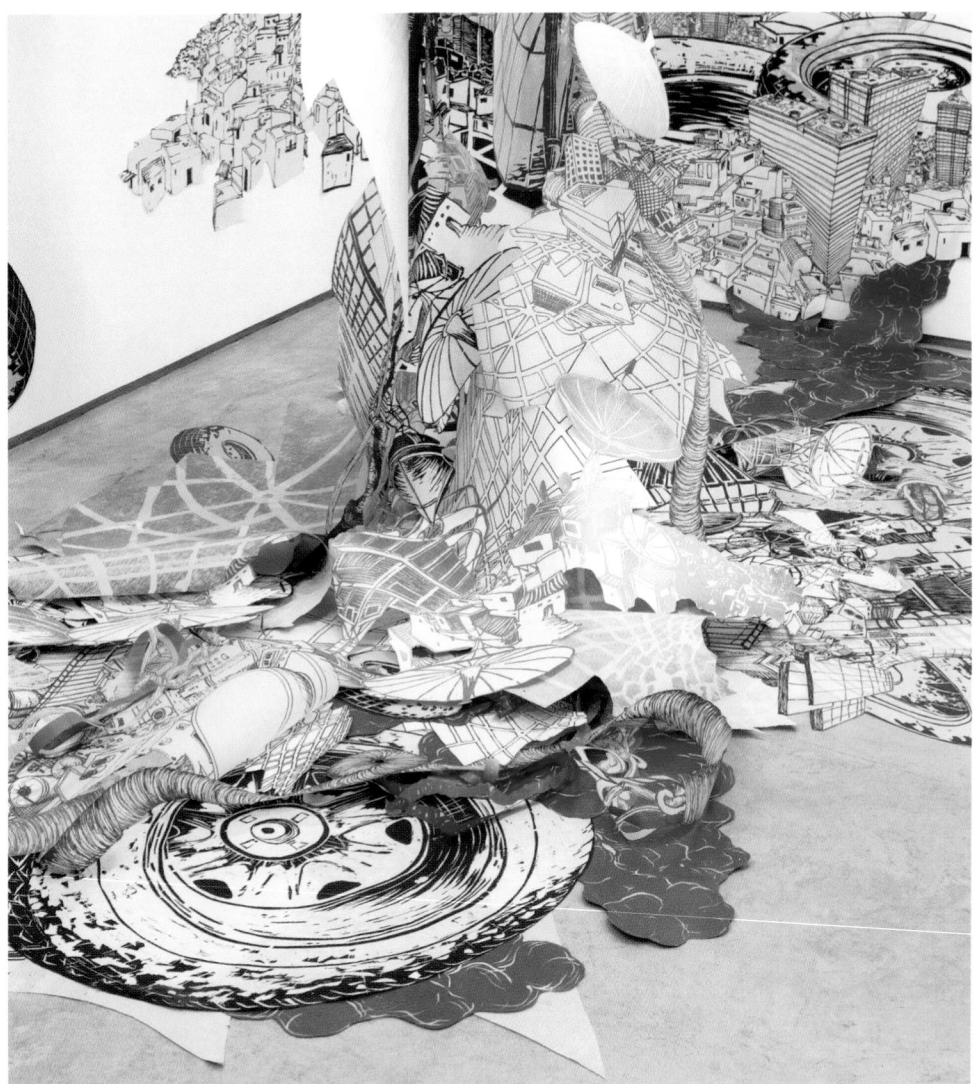

Vertigo (detail), Nicola López, 2005, mixed media. Dimensions variable.

together. She spreads all of the printed pieces out on the floor and uses them as building blocks to assemble the larger image, pinning them into place on the wall with pins, draping and wrapping them around parts of the architecture and letting them slither onto the floor.

Nicola states that her method feels very much like making a drawing with pre-fabricated elements.

Mirta Kupferminc (Argentina): Photographic emulsion and digital print

Mirta trained and started working as an artist at a very young age. Most of her work deals with issues of identity, drawing on her own background as a Jew and also on family experiences.

She works with the reinterpretation of myths and cultural issues. She integrates printmaking in different ways into her work, in artists's books, installations, videos and performance.

One of her latest works is *Borges y la Cabala*, in which she worked in collaboration with writer Saúl Sosnowski making an art book, a gigantic kaleidoscope-like installation nine metres tall, and an installation called *Ser Testigo*, meaning 'to be a witness', which alludes to a Hebrew ritual Shema Israel, which calls on the unity of God. In this ritual one prays with covered eyes in an attitude of introspection.

The printed glass at the bottom of the images represents each of the letters of the full prayer; only the last letter of the first and last words are printed, which makes the word Ed which means 'witness' in Hebrew.

The technique that the artist has used for this piece is traditionally used in photography, coating the paper (Arches 300gsm) with a photosensitive solution

Ser Testigo (To be a witness), Mirta Kupferminc, 2006, glass, paper and wood. 11.5 × 16.5ft / 3.5 × 5m.

Ser Testigo (To be a witness) (detail), Mirta Kupferminc, 2006, glass, paper and wood. 11.5 × 16.5ft / 3.5 × 5m. Different tonal results in the images depend on the different times of exposure.

that develops when exposed to the sunlight. The better the intensity of the colour one will get as a result depends on how long it is left under the sun, the season and the intensity of sunshine.

It could be left out from one minute to 20 minutes. It is very important to use a fixative bath with Hiposulfito to fix the image and stop the development process, making sure no colour changing will occur.

Julie Hoyle (UK): Screenprint on Perspex

Whilst considering the subject of the reinvention of nature through technology, Julie became interested in how the use of internet communication allows us to think about space, time and identity in another way. Unlike face-to-face communication, a disembodied relationship in cyberspace enables a flexible identity, social multiplicity, a transcendence of space and a stretching of time.

Julie's recent works, using light and shadow, were constructed in response

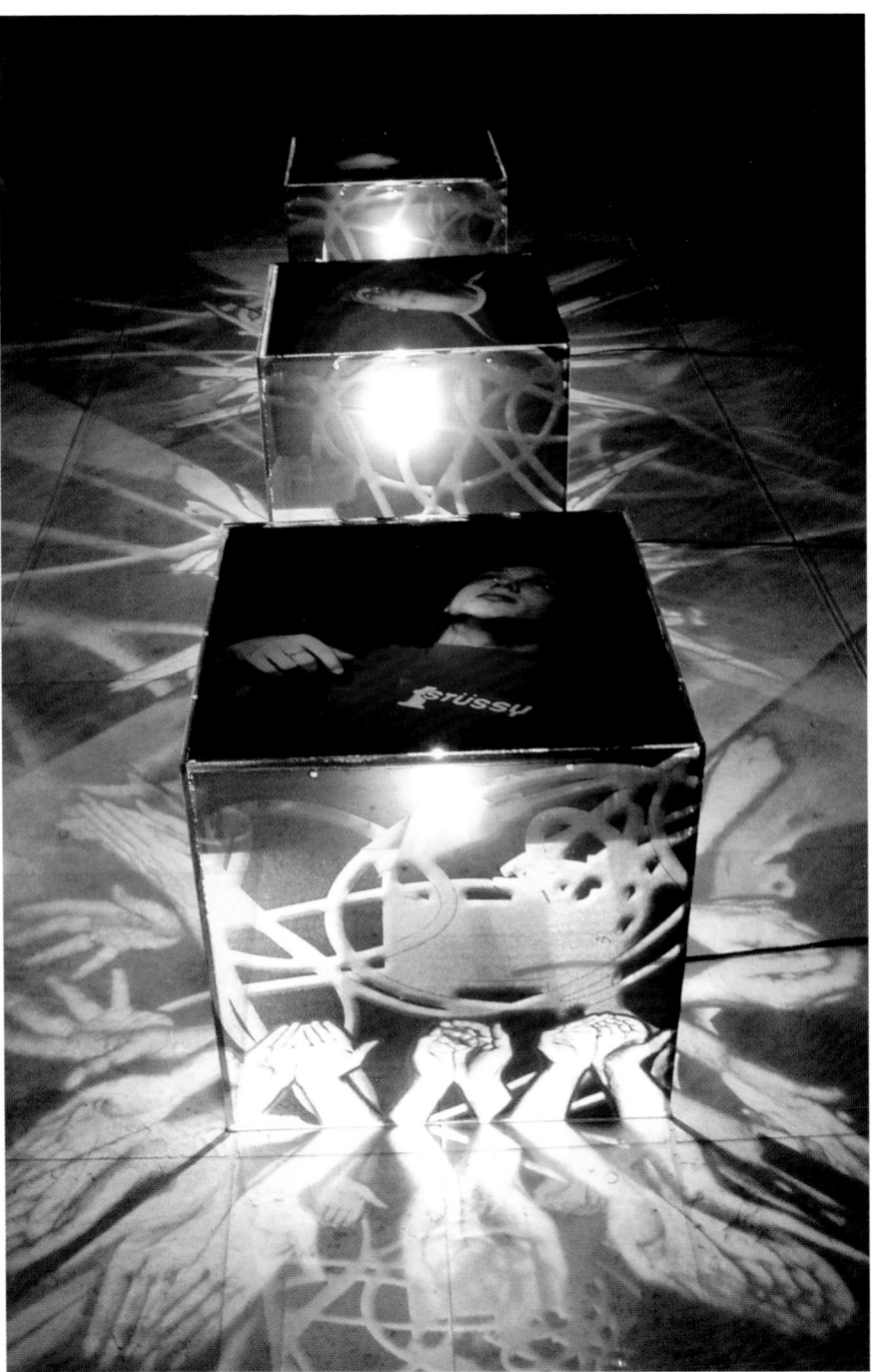

Head in a Box, Julie Hoyle, 2003, light and shadow installation, screenprint, Perspex, halogen light. Dimension variable. A set of three screenprinted Perspex boxes with three hybrid prints housed in the dropped tops is lit from the inside with halogen lights to cast shadows.

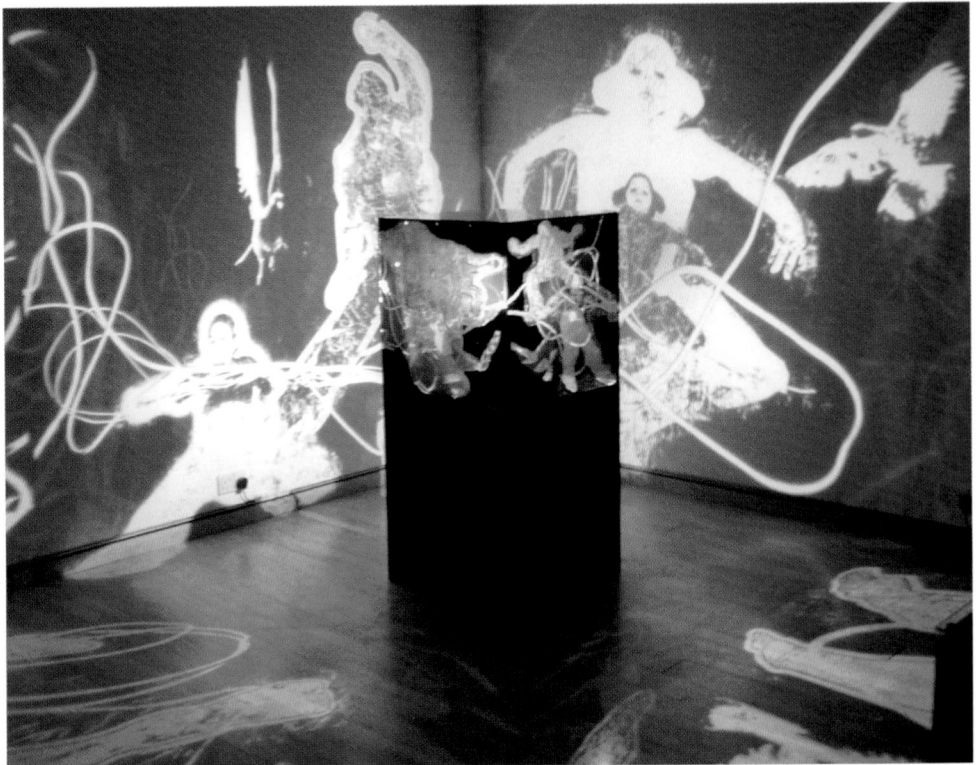

Dream Box, Julie Hoyle, 2004, light and shadow installation,. screenprint, Perspex and halogen light. Dimensions variable. On location at the Menier Gallery, London, a large double tier screenprinted box was installed to cast shadows around the various textured walls of the gallery space. The shadows had space to fall onto the floor, ceiling and walls. They created different effects on the brick, wood and plaster.

to the concept of cyberspace: a place that you cannot actually go to because it doesn't exist on any physical level, but which can be travelled through and endlessly explored entirely in someone's head. In fact, bodily, the only space occupied is the physical space that is in front of the computer; nevertheless, the geography travelled is real, and the relationships made are real, and all this is maintained in a space that cannot be located or experienced anywhere else but in the person's mind.

The light boxes are made using digital images. The artist uses photographs, drawings or scanned objects screenprinted onto Perspex using a photo stencil technique prior to construction and lit with Halogen light specifically to cast shadows; they fill and affect the space they occupy with large projected textural images.

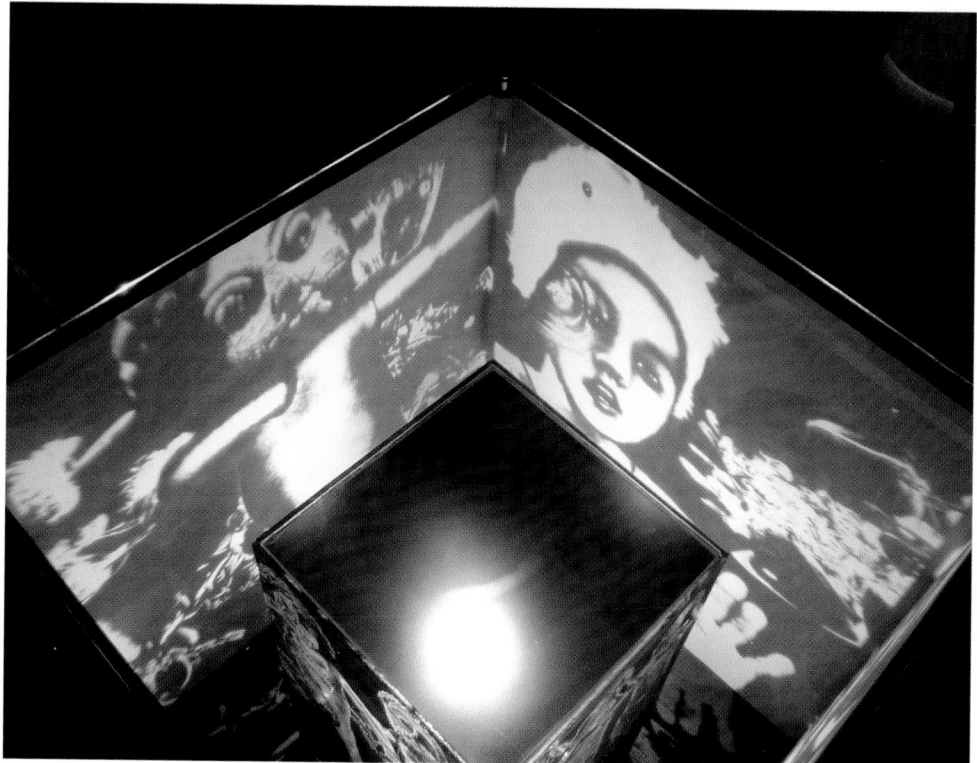

Lucid Dream Box, Julie Hoyle, 2005, screenprint, Perspex, halogen light, MDF. Dimensions 24 × 24 × 35.5in. /60 × 60 × 90cm. *Lucid Dream* is a box within a box. The outer box is made out of MDF and creates a miniature dark room, viewed through a floating glass top from above. Shadows are cast onto the interior walls of the box and are reflected on the glass bottom.

Steps:
- Prepare the Perspex, drilling small holes for ventilation; this is to help keep the box cool while lit.
- Degrease all Perspex with methylated spirit.
- Raise the screen bed, allowing for the depth of the Perspex.
- Make sure the vacuum is strong enough to hold the Perspex in place and print using a good quality opaque ink.
- Construct boxes using corner clamps, and using a fine brush, glue the sides together using Tensol 70 and EVO PLAS range, following the manufacturer's instructions.
- The design of the box should account for the size of the lamp. Halogen lights vary in strength from as little as 5 watts to over 50 watts, and can be bought from DIY stores. The height of the lamp-stand inside the box will alter the size of the shadows, as will the situation of the box within the room.

■ 2.2 MOVING IMAGE

Alexia Tala (UK – Chile): 16mm film on Lazertran™ and hand-painted film

Danny's Diary was a collaboration between the artist and her son, Daniel Foot.

Her ongoing preoccupation with memory and identity led her to embark on this project as an insight into the memory of her son, who was born with Down's syndrome. Research shows that people born with Down's syndrome suffer from problems with short-term memory and have difficulty articulating narratives.

The drawings are from a diary by Daniel of a trip he made without his mother to the island of Chiloé, in the south of Chile.

The film was made by washing the emulsion off with chlorine. The film was left in chlorine for three minutes and then the emulsion was wiped away with a soft cloth and rubber gloves. Once the emulsion was off, the film was well rinsed and dried.

Drawings were made on paper with black markers which were then scanned, worked on using photoshop, and printed onto Lazertran™. Multiple prints (20–60 prints) of each drawing were made at a size of 16mm.

The film was hand coloured, using Indian inks and glass paint before sticking the imagery to it.

The printed Lazertran™ was cut into strips and, following the instructions of the manufacturer, it was wetted and slid onto the film.

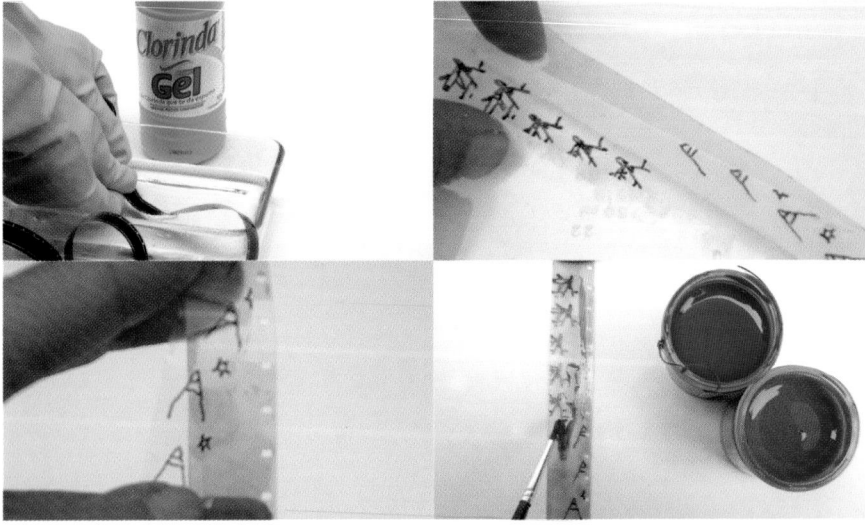

Danny's Diary, Alexia Tala, 2008, 16mm film, Lazertran™, drawings and hand painted film. Duration: 1.55 minutes.

16mm film on safmat, letraset and glitter

The film *Me, Me* is based on children's ideas of autobiography and portrait. For this film many children and young teenagers collaborated by drawing their own self portrait.

The film emulsion was removed (see above) and the same process was used for the imagery.

Drawings were made on paper with black markers, and magazine images were added as collage. The final pieces were then scanned and printed onto Safmat. Multiple prints (20–60 prints) of each drawing were made at a size of 16mm.

The difference between Safmat and Lazertran™ is that Safmat is a transparent adhesive paper that can be printed on the computer. Safmat sits on top of the film, unlike Lazertran™ which adheres and becomes part of the film. Safmat has a matt effect on the projection whereas Lazertran™ is totally transparent where the image was not printed. So the colours on the film are slightly altered.

Letraset was added on top and glitter glue was added in some areas.

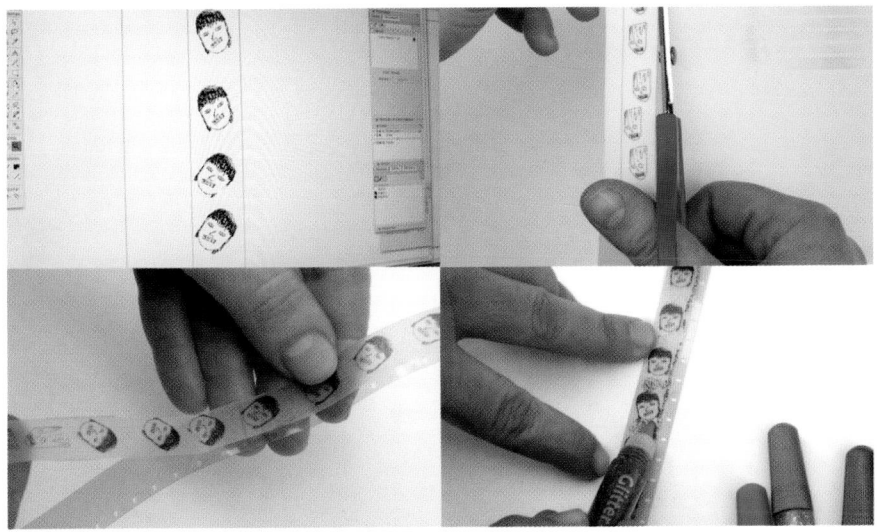

Me, Me, Alexia Tala, 2005, 16mm film, Safmat, Letraset, glitter and drawings. Duration: 1.25 minutes.

Mirta Kupferminc and Mariana Sosnowski (Argentina): Etching animation

Mirta (see page 89) joined forces and embarked on a collaboration with Mariana Sosnowski, an Argentinean visual artist who specialises in animation.

They created *En Camino (On the Way)*, a video animation using many of the characters that Mirta creates for her etchings, which Mariana then gave movement to. The video deals with the Argentinean reality of migration and mobility in a country in constant financial crisis.

The original images were printed in colour and black and white; some images remained black and white and others were hand painted. All images were then scanned and manipulated with the computer software.

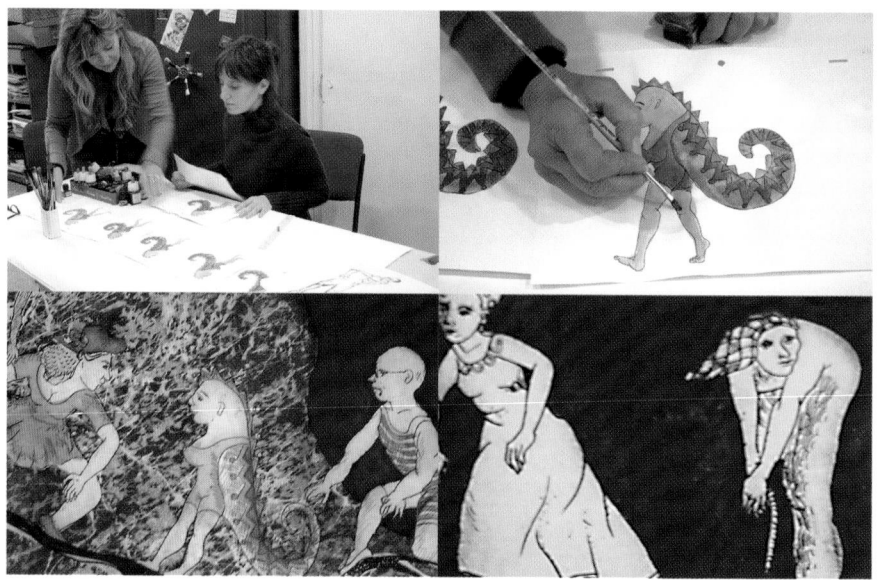

En Camino (On the Way), Mirta Kupferminc and Mariana Sosnowski, 2004, animated etchings. Duration: 8.32minutes.

Felix Lazo (Chile): Scanned etchings animation

Felix's work deals with issues of perception and cognition. It questions how we relate to what is received by our senses and how we interpret and assign a meaning to this information.

His latest interest is in animation and new media, exploring the possibilities that technology provides and mixing it with sound. He explores the possibility of creating an artwork that becomes an experience deep enough to transform our neuronal conditioning and present a new reality.

This video is a natural result of a process that started as a series of experiments done with printmaking. This video originates from an idea of creating a series of modular works in etchings. Four series each were done with a module that repeated itself. He printed the modules and then scanned them into the computer to start working the colours and the different possibilities of the modules.

Steps:
- Images are scanned etchings on paper, processed in Macromedia Flash™, After Effects™, Artmatic™.
- The sound part is produced in SuperCollider, iDrum™, Soundtrack Pro™ and others.

The whole video, the rhythm and the music tries to recapture the first raw and primitive feeling of the burned copper plates.

Tuk-Ok, Felix Lazo, 2007, scanned etchings animation. Duration: 7.54 minutes

Marcus Rees Roberts (UK): Films

Marcus started making etchings back in 1970. He always felt influenced by Bertolt Brecht. He was aware that there were, in both the cinema and printmaking, two parallel traditions: the mainstream and another fragmented tradition which subverts the mainstream.

Since his beginning as an artist, he wanted his work to be subversive in other ways too. He felt very strongly that he didn't want his work to be limited to the decorative print that only qualifies for being hung on the wall and wished his work to go beyond that. When most prints in the seventies were big, colourful and beautiful, his prints were small etchings, black and white, with fragments of images and text, different styles, jokes, cartoons, sometimes overlaid with almost illegible layers; the tone was ironic, satirising current political and intellectual pretensions.

He began to make films partly because the technology was easily available to him, and he could work in the same way as in his etchings – using layers. He always finds it intriguing to see what can be achieved by working in a new medium.

'Although the films do not have the tactility of an etching or a book, but they do have the ability to develop from one image to another: this is something an etching does not have. Even a series of etchings or an artist's book cannot play with tension, anticipation, echoes of previous images, and memory in the way a film can. I do not, at the moment, want to make "movies"; I want my images to move, but not like those in a film, where one image follows another with the logic that the movie-camera inevitably gives. I want my images to move from one to the other, sometimes with a sort of poetic logic, and sometimes with a jarring oddness.'

The film called *Letters to a Man at the Border* is related to an Artist's Book previously made by Marcus, titled *A Room in Portbou*. It refers to the last night of the great German critic Walter Benjamin. In 1940, he had been trying to escape Nazi occupied France. In desperation, he crossed the Pyrenees by foot and arrived at the dusty border town of Portbou. Here, he was hoping to obtain a permit to travel through neutral Spain to Portugal, and from there take a ship to the US. Unfortunately, he was not allowed to remain in Spain, and he knew that he would be returned to France the following morning. There he would be handed back to the Gestapo. He took his own life in his hotel room.

Bertolt Brecht wrote in a poem

'In the end, confronted by an impassable frontier,
 You crossed, they say, a passable one.'

(Brecht Poems, 1913–1956, published by Methuen, London, 2000, page 363.)

Letters to a Man at the Border, Marcus Rees Roberts, 2006, etching, drawings, photographs and film fragments of archive footage. Duration: 12:40 minutes.

Steps:

- The artist makes hundreds of images, from drawings, prints, collages, photographs, and newspaper fragments.
- They are then altered in order to make them suitable for the film on Adobe Photoshop®. He frequently prints an image, works on it again by hand, scans it, and perhaps even repeats the process again. He also uses several versions of one image, perhaps by adding another barely discernible layer with Photoshop®. When the images are ready, they are transferred to Adobe Premiere® to make the film.
- Sound is then added. He prefers using brief fragments of sound and joining and mixing them together.

Klaudia Kemper (Chile): Woodcut animation

Klaudia is a Chilean artist who lives and works in Santiago, Chile.

Her work consists of mainly animations and installations. She explores issues of time and reconstruction in her work.

The animation featured here is titled *Natural Things* and the starting point for this piece was a written piece by a nine-year-old child about all things, natural and not. She chose to work with it as she felt attracted to the simplicity of a child's vision. She translated that simplicity into the way she created the visuals in woodcut in order to construct the animation.

She is also interested in how the naïve vision of a child is received by an adult viewer who already has historical luggage that has structured him/her in many ways.

Natural Things was created using woodcut plates which were scanned into and then retouched in Adobe Photoshop® and then made into a sequence. The number of woodcut plates and the number of images are not the same as each plate was scanned at different stages of the cutting process in order to get the different images required for the animation; this part of the process could be compared to the artist's proof stage.

Many different types of software were used in order to make the piece. For images Klaudia used Adobe Photoshop®, After Effects™ and Final Cut Pro™. To incorporate sound the artist used a keyboard and GarageBand™.

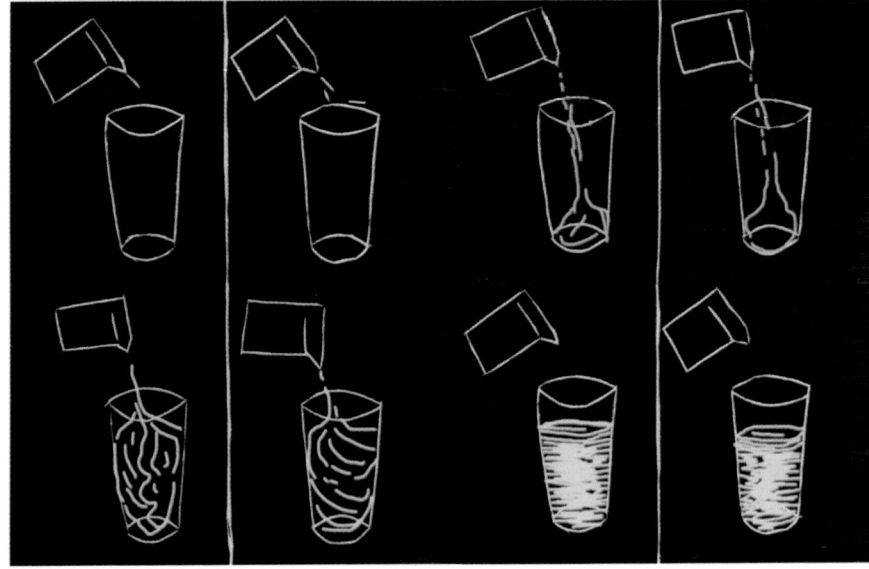

Natural Things, Klaudia Kemper, 2007, woodcut animation. Duration: 2 minutes.

CONCLUSION

Artists have continually adapted to new technologies and materials throughout history. Modern art characterised this with artists working across and moving between various disciplines. Contemporary art has taken this further by defining the artist as a 'visual artist', creating work that encompasses many different disciplines, materials, techniques and presentation methods, often within the same body of work to portray their issues of concern.

Printmaking, as discussed here, is an art form going through significant change, with its definition widening to include digital technologies, photography and mixed media. This book hopes to add to the understanding and discussions of these changes and highlight some of the artists working in methods that challenge our conceptions of printmaking. By showing how these artists have explored new techniques, materials and display methods which have used print processes I hope I have introduced the reader to some of the creative experimentation currently being undertaken.

Who knows how much further, and in what direction this will lead, but experimenting is one of the few words with no set parameters. Artists will continue to challenge our pre-conceptions and find innovative ways of using and displaying their work using print, it will be an exciting area of artistic development to keep an eye on!

■ LIST OF SUPPLIERS

United Kingdom

A P Fitzpatrick
142 Cambridge Heath Rd
London E1 5QJ
Tel: 020 7790 0884
www.apfitzpatrick.co.uk
(Fluorescent pigments, Perspex, glue–
Tensol 70)

Aquarius Plastics Ltd
Unit 1 Eydon House
Midleton Industrial Estate
Guildford
Surrey GU2 8XW
Tel: 01483 576044
www.aquariusplastics.co.uk
(Perspex suppliers)

Atlantis Art Supplies
7–9 Plumbers Row
London E1 1EQ
Tel: 020 73778855
www.atlantisart.co.uk

Daler-Rowney Ltd
Head Office
PO Box 10
Bracknell RG12 8ST
Tel: 01344 461 000
www.daler-rowney.com

Falkiner Fine Papers Ltd
76 Southampton Row
London WC1B 4AR
Tel: 020 7831 1151
www.falkiners.com

Gilbert Curry Industrial Plastics Co Ltd
16 Bayton Rd
Bayton Rd Industrial Estate
Coventry CV7 9EJ
Tel: 024 76588 388
www.gcip.co.uk
(Perspex suppliers)

Glass Scribe
Spencer House
Caberfeidh Avenue
Dingwall IV15 9TD
Tel: 01349 867 088
https://.secure.glassscribe.com

Intaglio Printmakers
62 Southwark Bridge Rd
London SE1 0AT
Tel: 020 792 82 633
www.intaglioprintmaker.com

John Purcell Paper
15 Rumsey Rd
London SW9 0TR
Tel: 020 7737 5199
www.johnpurcell.net

Khadi Handmade Papers
Chilgrove
Chichester PO18 9HU
Tel: 01243 535314
www.khadi.com

Lazertran Ltd UK
8 Alban Square
Aberaeron
Ceredigion SA46 0LX
Tel: 01545 571 149
www.lazertran.com

L Cornelissen and Son Ltd
105 Great Russell Street
London WC1B 3RY
Tel: 020 7636 1045
www.cornelissen.co.uk

London Graphic Centre
16 Shelton Street
London WC2H 9JL
Tel: 020 759 4545
www.londongraphics.co.uk

R K Burt
57 Union Street
London SE1 1SG
Tel: 020 7407 6474
www.rkburt.co.uk

The Blast Shop
S Critchley and Son
Agecroft Memorial Works
Langley Rd, Pendlebury
Manchester M27 8SS
Tel: 0161 351 6545
www.theblastshopinc.co.uk

T N Lawrence and Son Ltd
208 Portland Rd
Hove BN3 5QT
Tel: 0845 644 3232
www.lawrence.co.uk

Yorkshire Printmakers and Distributors Ltd
26–28 Westfield Lane
Huddersfield
West Yorks HD8 9TA
Tel: 01924 840514

Europe

Arjormari Diffusión
66–68 Rue Du Dessous Des Berges
75013 Paris
France
Tel : (+33) 01 44 062800
(paper suppliers)

Paperki Handmade Papers
Apartado de Correos 106
20280 Hondarribia
Spain
Tel: (+34) 943 640 555
www.paperki.com

Rigacci
Via dei Servi 71
Florence
Italy
Tel: (+39) 055 216206
(art materials and paper supplier)

Sebino Colori
Via Farini 21-E
40124 Bologna
Italy
Tel: (+39) 051 222590
www.sebinocolori.it

The Printmakers Experimentarium
Trepkasgade 8
DK-2100 Copenhagen
Tel: (+45) 35 353907
www.grafiskeksperimentarium.dk

North America

American Printing Equipment Supply Co.
12–25 9th Street
Long Island City

NY 11101-491
Tel: (+1) 718 729 5779
www.americanprintingequipment.com

Bookmakers
Room 410
2025 Eye Street NW
Washington DC 20006
Tel: (+1) 202 296 6613
(Art and binding supplies)

Lazertran Ltd USA
C/O D2F
1501 W. Copans Rd
Suite 100
Pompano Beach
Florida 333064
Tel: (+1) 1 800 245 7547
www.lazertran.com

New York Central Art Supply Inc
62 Third Avenue
New York, NY 10003
Tel: (+1) 212 473 7705
www.nycentralart.com

Pearl
308 Canal Street
New York, NY 10013
Tel: (+1) 212 431 7932
www.pearlpaint.com

R&F Paints
84 Ten Broeck Avenue
Kingston
New York 12401
Tel: +1 1 800 206 8088
www.rfpaints.com

Solarplate Etching
Hampton Editions, Ltd
P.O.Box 520

Sag Harbor
NY 11963
Tel: (+1) 631 725 3990
www.solarplate.com

The Japanese Paper Place
77 Brock Avenue
Toronto
Ontario
Canada M6K 2L3
Tel: (+1) 416 538 9669
www.japanesepaperplace.com

Australia

Art Papers
243 Stirling Highway
Claremont
Western Australia 6010
Tel: (+61) 8 9384 6035

Jacksons Drawing Supplies Pty Ltd
Head Office
594 Hay Street
Jolimont
Tel: (+61) 8 9383 9777
www.jacksons.com.au

Premier Art Suppliers
43 Gilles Street
Adelaide
Tel: (+61) 8 8212 5922
www.premierart.com.au

The Student Supply Shop
Old College of Art
Morningside
Brisbane
Queensland 4170
Tel: (+61) 7 339 3363

■ WORKSHOPS AND STUDIOS

Most workshops and studios have residency schemes that national and international artists can apply for.

United Kingdom

Artichoke Workshop
Unit S1 Bizspace
245A Coldharbour Lane
London SW9 8RR
Tel: 020 7924 0600
www.artichokeprintmaking.com

Belfast Print Workshop
Cotton Court
30–42 Waring Street
Belfast BT1 2ED
Tel: 028 9023 1323
www.belfastprintworkshop.org.uk

Edinburgh Printmakers Workshop
23 Union Street
Edinburgh EH1 3LR
Tel: 0131 557 2479
www.edinburgh-printmakers.co.uk

Glasgow Print Studio
22 King Street
Glasgow G1 5PQ
Tel: 0141 552 0704
www.gpsart.co.uk

London Print Studio
425 Harrow Rd
London W10 4RE
Tel: 020 8969 3247
www.londonprintstudio.org.uk

Seacourt Print Workshop
Unit 33 Dunlop Industrial Estate
8 Balloo Drive

Bangor, Co. Down
Northern Ireland BT19 7QY
Tel: 028 9146 0595
www.seacourt-ni.org.uk

The Curwen Print Study Centre
Chilford Hall
Linton
Cambridge CB1 6LE
Tel: 01223 892 380
www.curwenprintstudy.co.uk

The Wyvern Bindery
56–58 Clerkenwell Rd
London EC1M 5PX
Tel: 020 207 490 7899
www.wyvernbindery.com

Europe

Art Studio Fuji
Via Guelfa 79A/85
Florence 50129
Italy
Tel: (+39) 55 216877
www.artfuji.it

Il Bisonte
Via San Niccolo 24 Rosso
Florence
Italy
Tel: (+39) 055 234 2585
www.ilbisonte.it

Scuola Internazionale di Grafica Venecia
Cannaregio 1798
30121 Venice

Italy
Tel: (+39) 041 721 950
www.scuolagrafica.it

The Printmakers Experimentarium
Trepkasgade 8
DK-2100 Copenhagen
Tel: (+45) 35 353907
www.grafiskeksperimentarium.dk

North America

Creative Capital
65 Bleeker Street
7th Floor
New York
NY 10012
Tel: (+1) 212 589 9900
www.creative-capital.org

Graphic Studio USF
3702 Spectrum Boulevard
Suite 100
Tampa
Florida 33612-9498, USA
Tel: (+1) 813 974 3503
www.graphicstudio.usf.edu

Open Studio
401 Richmond Street West, Suite 104
Toronto
Ontario
Canada M5V 3A8
Tel: (+1) 416 504 8238
www.openstudio.on.ca

Paula Roland Workshop
523 Cortez Street
Santa Fe
New Mexico, NM 87501, USA
Tel: (+1) 505 989 3419
www.paularoland.com

R&F Paints
84 Ten Broeck Avenue
Kingston
New York 12401
Tel: (+1) 800 206 8088
www.rfpaints.com

**The Judith K. and David J. Brodsky
Center for Print and Paper**
Mason Gross School of the Arts
33 Livingstone Avenue
New Brunswick NJ 08901
Tel: (+1) 732 932 2222 Ext 838
www.brodskycenter.org

Australia

Australian Print Workshop
210 Gertrude Street
Fitzroy
Victoria 3065
Tel: (+61) 3 9419 5466
www.australianprintworkshop.com

South America

Proyecto ACE
Conesa 667, Altos
C1426 AQM Buenos Aires
Argentina
Tel: (+54) 11 4551 3218
www.proyectoace.com.ar

Taller Arte Dos Gráfico
Carrera 14 n.75–29
Bogotá
Colombia
Tel: (+57) 1 249 4755
www.artedos.com

■ USEFUL WEBSITES

www.alancristea.com
www.artksp.be
www.artworldprint.com
www.fineartgicleeprinters.org
www.lessedra.com
www.manhattangraphicscenter.org
www.moma.org

www.northernprint.org.uk
www.paragonpress.co.uk
www.philagrafika.org
www.southerngraphics.org
www.tate.org.uk
www.triennial.ee
www.wsworkshop.org

■ ARTISTS' WEBSITES

Daniel Alcalá www.arroniz-arte.com
Helen Bridges www.helenvbridges.co.uk
Juan Castillo www.cnca.cl/galeriagm/castillo_B.htm
Janet Curley Cannon www.jcurleycannon.com
Rebecca Gouldson www.rebeccagouldson.co.uk
Oona Grimes www.daniellearnaud.com/artists/artists-grimes.html
Brenda Hartill www.brendahartill.com
Jan Hendrix www.janhendrix.com.mx
John Hitchcock http://website.education.wisc.edu/jhitchcock/
Thomas Kilpper www.kilpper-projects.net
Libby Hague www.libbyhague.com
Julie Hoyle www.juliehoyle.com
Klaudia Kemper www.klaudia-kemper.blogspot.com
Mirta Kuperminc www.mirtakuperminc.net
Felix Lazo www.lazo.cl
Nicola López www.nicolalopez.com
Claire Nash www.printmaking.org.uk
Marilene Oliver www.marileneoliver.com
Elizabeth Peer www.lizzieart.co.uk
Susie Ranager www.susieranager.com
David Rhys Jones www.davidrhysjones.com
Marcus Rees Roberts www.prattcontemporaryart.co.uk
Paula Roland www.paularoland.com
Zoë Schieppati-Emery www.zoe-schieppati-emery.com
Agathe Sorel www.agathesorel.co.uk
Mariana Sosnowski http://marianasosnowski.blogspot.com
Alexia Tala www.alexiatala.com
Dan Welden www.danwelden.com

■ BIBLIOGRAPHY

Duro, Paul (1996), *The rhetoric of the frame – essays on the boundaries of the artwork*, UK, Cambridge University Press, 1996

Klee, Paul (1945), *Paul Klee statements by the artist*, second edition, New York – USA, Museum of Modern Art, Plantin Press

Noyce, Richard (2006), *Printmaking at the Edge*, London – UK, A&C Black Publishers.

Rainbird, Sean (2004), *Print Matters: The Kenneth Tyler Gift*, London – UK, Tate Publications.

Saunders, Gill and Miles, Rosie (2006), *Prints Now: Directions and Definitions*, London – UK, V&A Publications.

Tallman, Susan (1996), *The Contemporary Print: From Pre-Pop to Post Modern*, New York – USA, Thames and Hudson Publications

Welden, Dan and Muir, Pauline (2001), *Printmaking in the Sun*, New York – USA , Watson and Guptill Publications.

Wye, Deborah (2004), *Gauguin, Paul – Toulouse-Lautrec, Henry – Bonnard, Pierre – Lissitzky, El – Picasso, Pablo – Pollock, Jackson – Richter, Gerhard – Rosenquist, James – Carlos, Paul – Zichello, Chis*. Artists and Prints: Masterworks from the Collection of The Museum of Modern Art., New York – USA, The Museum of Modern Art Publications.

Wye, Deborah and Weitman, Wendy (2006), *Eye on Europe: Prints, Books and Multiples /1960 to now, New York – USA*, The Museum Of Modern Art Publications.

Wye, Deborah and Weitman ,Wendy (2002), *Thinking Print: Books to Billboards:1980–95*. New York – USA, The Museum of Modern Art Publications.

■ GLOSSARY

Alloy: a combination of two or more metallic elements which makes a new metal.

Anodised aluminium plate: an aluminium plate that has been coated with a protective oxide layer by the process of electrolysis.

Collagraph: a print made from a collaged plate. Different materials are glued to the plate to produce a more textured image.

Decal: a paper that has been previously prepared for transferring onto another material such as ceramics, glass, plastic or paper.

Emboss: the action of carving a pattern in relief, usually by pressing hard. When embossing on paper, a raised result of the image appears as the damp paper becomes moulded.

Encaustic medium: a mixture of 8/1 of beeswax and dammar resin respectively; they mix by melting with heat. Dammar resin is added in order to make it stronger.

Encaustic stick: crayons made out of encaustic medium and the addition of coloured pigments. Mica powders can be added to obtain an iridescent result.

Engraving: in printmaking this refers to the process of carving a pattern or design on a surface, usually by using carving knifes.

Gilding metal: a metal used to thinly cover another metal.

Gold leaf: gold which has been beaten into an extremely thin sheet, which is very delicate and easy to stick to any surface.

Glaze: the act of covering with glaze.

Hotbox: a wooden box with an aluminium top that is heated up by light bulbs. It is used for producing encaustic monotypes.

Inkaid: a trademark for products that offer the artist the chance to create different types of surfaces to print on to. It can be applied to wood, metal, paper, plastic and many other materials.

Lazertran: a trademark which produces waterslide decal transfer papers. It can be used with a digital printer or a photocopier and the images can be transferred on to different surfaces, such as glass, ceramics, metal, acrylic and others.

Lead: a highly toxic substance. Many adverse health effects can be suffered by exposure to lead.

Lenticular: serrated plastic that comes in different thicknesses. It prints in layers and gives the illusion of motion.

Linseed oil: a water-resistant slow drying oil that is extracted from flax seed.

Liquid light: a trademark which produces a photographic emulsion for printing on a wide range of surfaces such as fabrics, metal, wood, glass and others.

MDF: medium density fiberboard.

Monoprint: a 'one off' print. Monoprints are made by drawing and painting on a flat smooth surface; printing is done by hand burnishing or by running it through a press.

Mylar: a trademark strong and flexible semi-opaque polyester film; usually comes in rolls of 1.20m.

Paint stripper: a mixture of solvents designed to remove paint. It comes in liquid and gel form.

Patination: a superficial covering by coating a metal surface with an oxide.

Perspex / Plexiglass: two trademarks which have become generic names in the UK and USA, respectively, for acrylic sheets. It is a tough transparent plastic often used instead of glass. It comes in different sizes and thicknesses.

Phototransfer: a photographic paper coated with emulsion designed for photographic transfers on to different surfaces. It comes in the form of paper sheets.

Rubber stamps: stamps made out of rubber.

Screenwash: a solvent that removes the emulsion on the screen (silkscreen)

Silverplated: a coat of silver on top of another surface. It gives the illusion that the whole object is made out of silver.

Solarplate: a trademark light sensitised steel backed polymer material designed to create printing plates. It is exposed under UV light and developed with tap water. It is safer than traditional etching techniques.

Steel: a strong grey alloy. It is a mixture of carbon and iron. Steel plates are usually used for etching as a more economical alternative to copper.

Stop out: a varnish that is applied as a resist for acid to stop it eating into the metal plate.

UVLS varnish: an acrylic varnish with UltraViolet Light Stabilisers to prevent deterioration or discolouration.

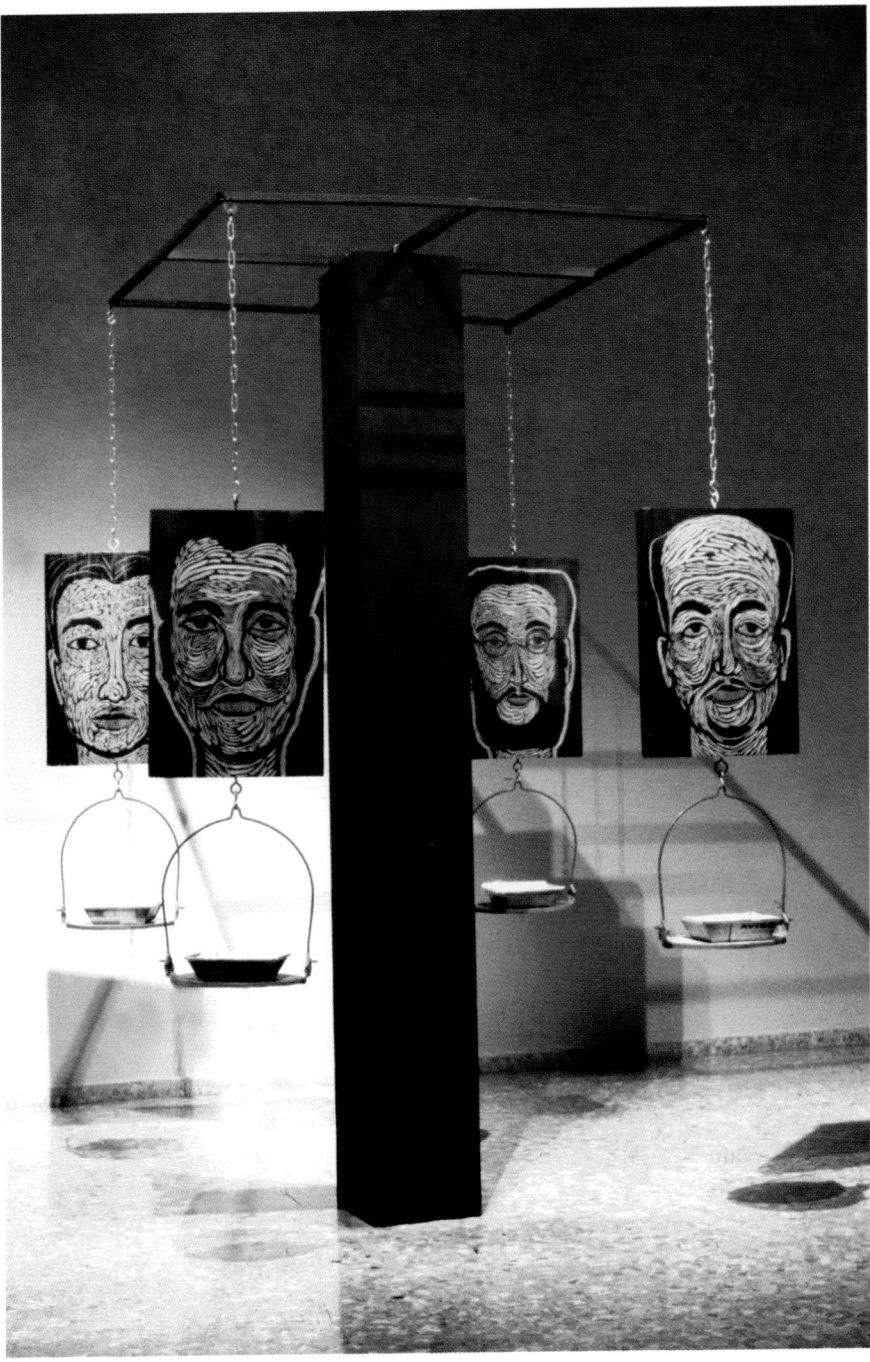

El peso de la conciencia (Conscience weight), Belkis Ramirez, 1993, carved and painted wood, steel chains and wooden construction frame. Dimensions variable.

INDEX

■ INDEX